Backyard Birds

WELCOMED GUESTS AT OUR GARDENS AND FEEDERS

BY STAN TEKIELA

Adventure Publications
Cambridge, Minnesota

DEDICATION

To my lovely daughter, Abby, with all my love.

ACKNOWLEDGMENTS

I would like to thank Agnieszka Bacal, who has been instrumental in obtaining some of the images in this book. For all that you do, thank you.

Many thanks to my good friends, colleagues and associates who help me in the pursuit of finding and photographing birds and bird nests: Rick Bowers, Susan Fagnant, Ron Green, William "Buck" Huber, and the Bird Collection, Bell Museum of Natural History, University of Minnesota (St. Paul).

Thanks also to Jim and Carol Zipp, good friends and wild bird store owners, for reviewing this book.

All photos by Stan Tekiela
Edited by Sandy Livoti
Cover and book design by Jonathan Norberg

10 9 8 7 6 5 4 3 2 1

Copyright 2016 by Stan Tekiela
Published by Adventure Publications
820 Cleveland Street South
Cambridge, Minnesota 55008
(800) 678-7006
www.adventurepublications.net
All rights reserved
Printed in China
ISBN: 978-1-59193-641-1; eISBN: 978-1-59193-658-9

TABLE OF CONTENTS

Just before daybreak on a warm spring morning I hear a male Northern Cardinal singing his crisp, clear "what-a-cheer" song. Shortly after, the female responds with her own special song. As the sun's warming rays slowly stream into my backyard, other birds join in with their own songs, completing the symphony. I look toward my feeding stations and see a myriad of small birds fluttering back and forth, enjoying the seeds I provided. Over the last 30 or more years, I've fed birds not only to draw them closer, but also to observe their behaviors and learn more about them.

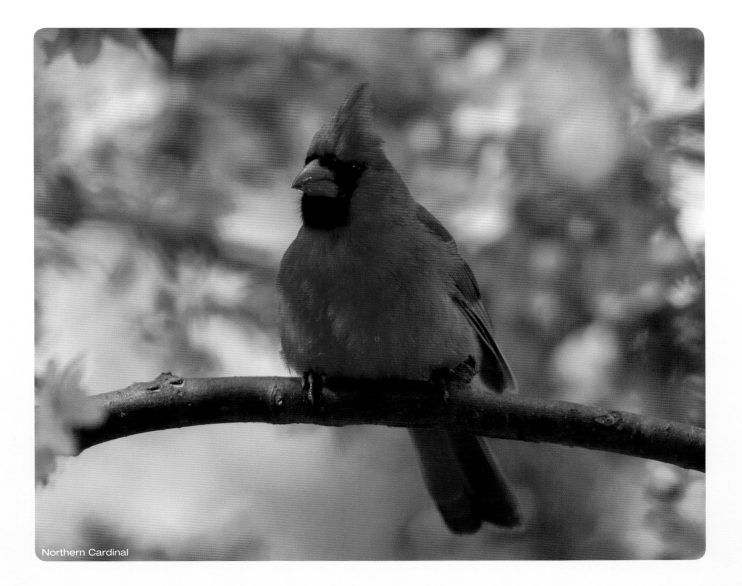

Northern Cardinal

5

MOVING INTO THE NEW WORLD

Over 60 million years ago, the Americas were connected to Eurasia. As the land split apart, several groups of birds became unique to the New World. Most notable were the hummingbirds. These tiny, iridescent jewels with lightning-fast wings are not found in the Old World. Many others, including warblers, tanagers, cardinals and blackbirds, evolved to be found solely in the Americas and became the common backyard birds that we love so much today.

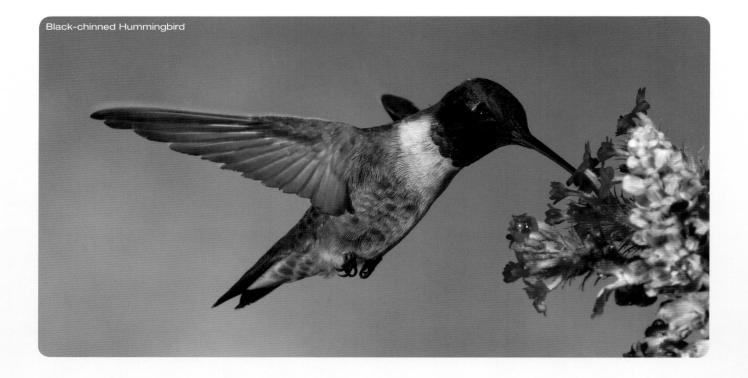

Black-chinned Hummingbird

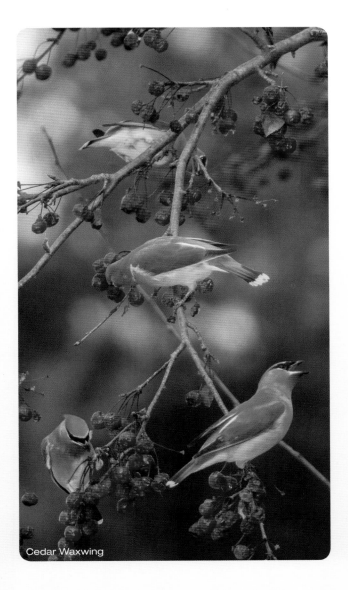

Cedar Waxwing

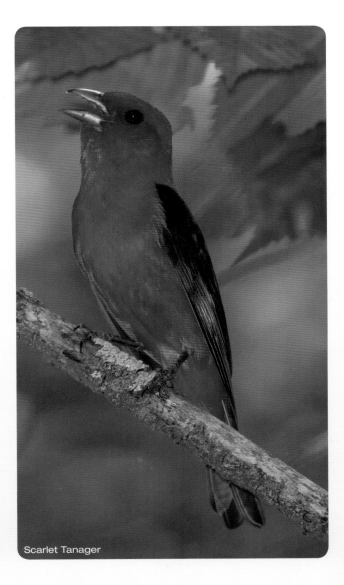

Scarlet Tanager

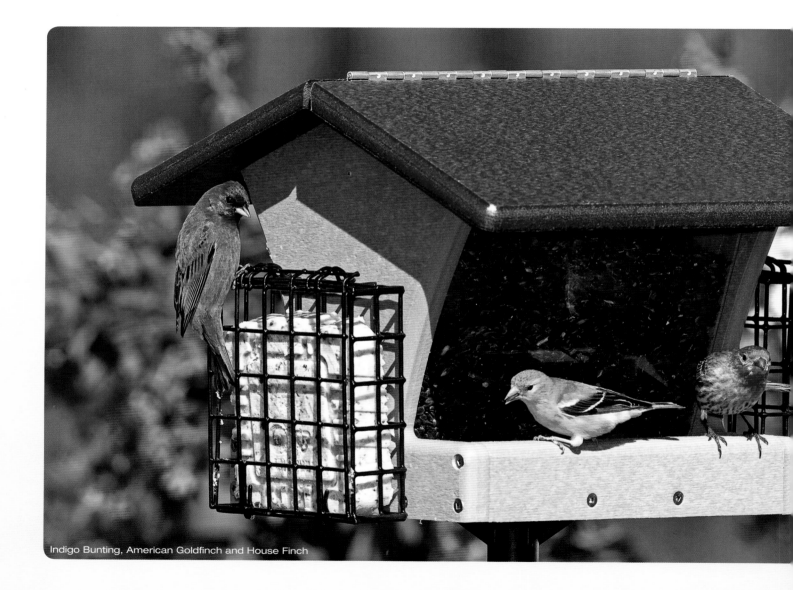

Indigo Bunting, American Goldfinch and House Finch

THE ORIGINS OF BIRD FEEDING

Backyard bird feeding is a relatively new pastime. It wasn't until after World War II that people started to feed birds for recreation. Eventually, when people moved off farms into urban and suburban settings, we started losing our relationship with the natural world. To reconnect, we began feeding the birds in our yards.

FAMILIES OF BIRDS

Most of our backyard birds are members of an order called Passeriformes. This order comprises about 60 percent of the approximate 10,000 bird species in the world and is divided into many families.

Turdidae is the family of thrushes and includes Wood Thrushes and American Robins. Icteridae encompasses the blackbird family. All of our orioles are in this group, as they are actually a type of blackbird.

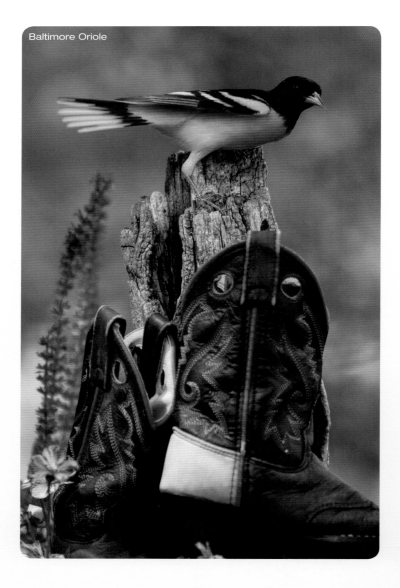

Baltimore Oriole

Black-capped and Carolina Chickadees, birds in the Paridae family, are directly related to the titmouse species, and are close relatives of Verdins and Bushtits. The Verdin is a sweet little bird of the American Southwest that often comes to nectar feeders and orange halves. It has rusty red shoulder patches that are mostly hidden except when they're on display during breeding season.

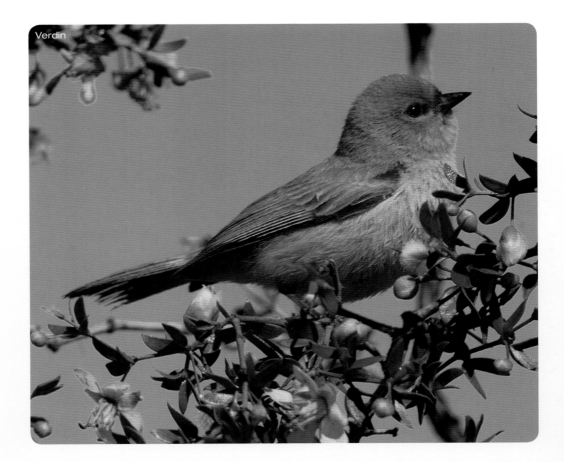

Verdin

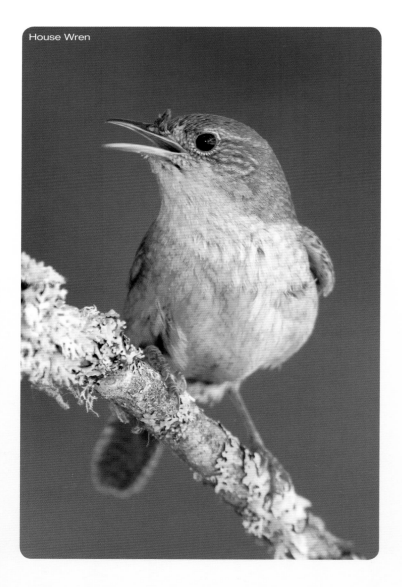

House Wren

Not all backyard birds come to feeders. Wrens, members of the Troglodytidae family, are common and often noisy backyard visitors. These birds sing from well before dawn into the evening darkness. House and Carolina Wrens are known for making nests in our yards with a variety of materials and serenading us with their love songs.

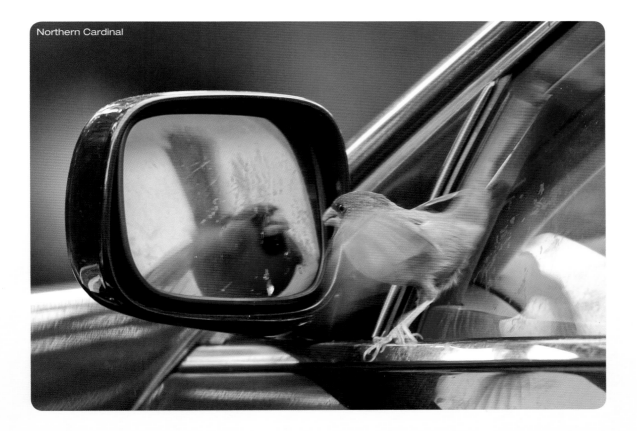

Northern Cardinal

Cardinals, grosbeaks and tanagers are not all in the same family, but many people see them at or near their feeders. These are some of the mostly brightly colored and highly specialized birds. The Northern Cardinal can be extremely territorial and is even known to fight its own reflection in a window or mirror. Grosbeaks are known for their ability to crack open seeds with their oversized bills. Tanagers have bills strong enough to open and eat a wide variety of fruit, which is a big part of their diet.

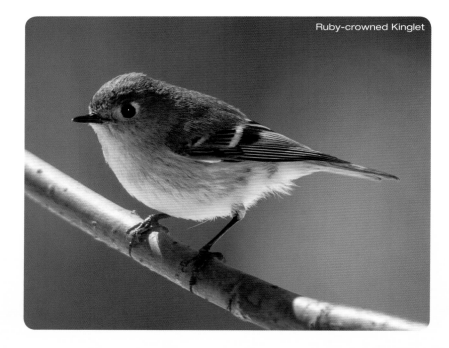
Ruby-crowned Kinglet

THE BACKYARD BIRDS

Most of our backyard birds are small. Take the Ruby-crowned Kinglet, for instance. At only 3–4 inches tall, it's one of the tiniest birds in your yard. Being petite and lightweight is an advantage for flight, and thousands of small bird species confirm this. Many of these birds are often called LBJ's or Little Brown Jobs—a fun way of saying they are difficult to identify.

Many of our backyard birds are also fabulous songsters. Have you ever noticed that it's the small birds that sing so much and so beautifully? This relates to their environment. When a tiny male bird is in a big forest with tall trees, thick underbrush and lots of shade, it's hard to be seen and attract a mate. So birds in these habitats sing complex, loud songs to get the job done. Birds of the prairie also sing loud, clear songs, but they do it for long-distance communication.

Tiny, brightly colored forest birds have another relationship with their surroundings. Small songbirds, such as Blackburnian Warblers, have bright feathers that shine in dimly lit habitat. Male birds need to be seen in the dark shadows under a tree canopy, and the males of many species are brightly colored, unlike the females. Their bold appearance conveys fitness and the ability to be a good provider and father.

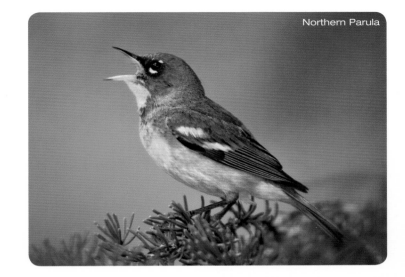

Northern Parula

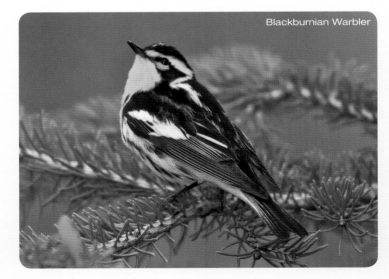

Blackburnian Warbler

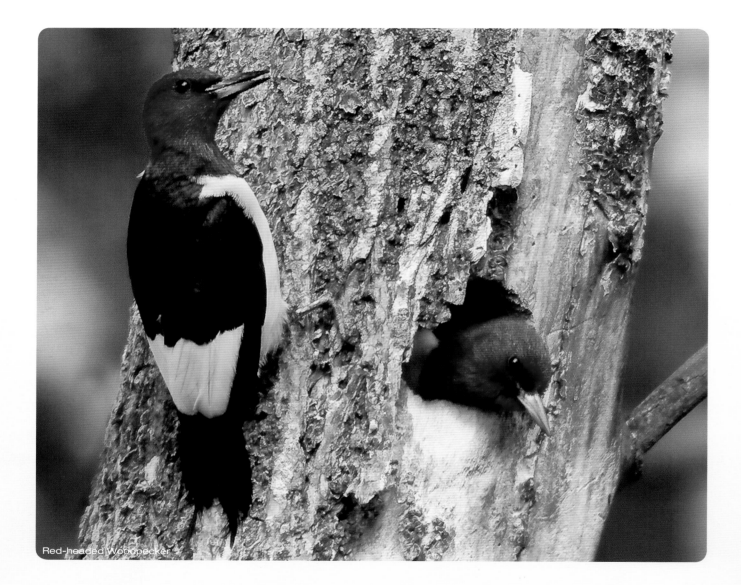

Red-headed Woodpecker

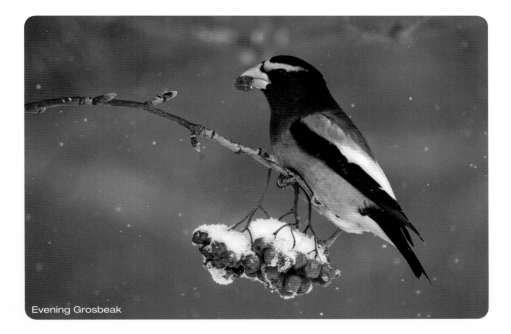
Evening Grosbeak

DECLINING POPULATIONS

Several reports from National Audubon Society show that some widespread and once common birds have declined dramatically. The Red-headed Woodpecker, which was thought to be the most common woodpecker in North America, declined upwards of 87 percent in the past 50 years. Once a common sight in many people's yards, it is now a rarity.

As short as 30 years ago, many people had Evening Grosbeaks coming to their feeding stations in winter. These birds had an 80 percent drop in population and now they are rarely seen.

Most of our common ground nesters, such as Western Meadowlarks, Bobolinks and Dickcissels, are in steep decline due to mowing and cutting tall grasses for livestock. Just at peak nesting time, farmers cut their tall grasses for hay and inadvertently wipe out the habitat for many groups of birds.

Throughout the eastern half of America, backyard bird populations are in big decline. Most of this is a result of clearing forests and grasslands for homes and shopping malls. With the nesting habitat destroyed, there's no place for the birds to reproduce. In general, many songbirds and backyard bird populations are down 50–70 percent from 50–75 years ago.

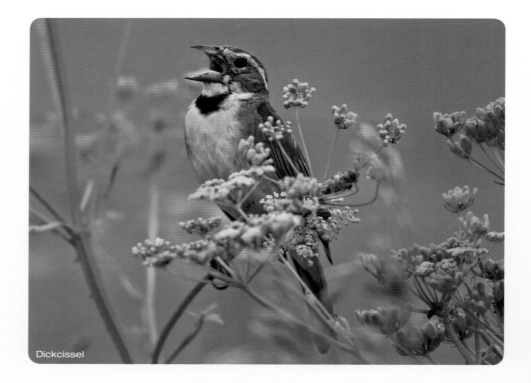
Dickcissel

SAVING OUR BACKYARD BIRDS

The key to reversing the decline in backyard birds and songbirds is to preserve their habitat. You can start by converting your yard into nesting and feeding habitat, and at the same time, curb the use of insecticides and herbicides. Bird feeding and providing water for them are excellent ways to draw birds to your personal wildlife refuge.

In addition, you can support environmental organizations that restore or preserve habitat and make donations to bird conservation organizations. You can also volunteer at your local wildlife rehabilitation clinic or nature center for a more hands-on approach.

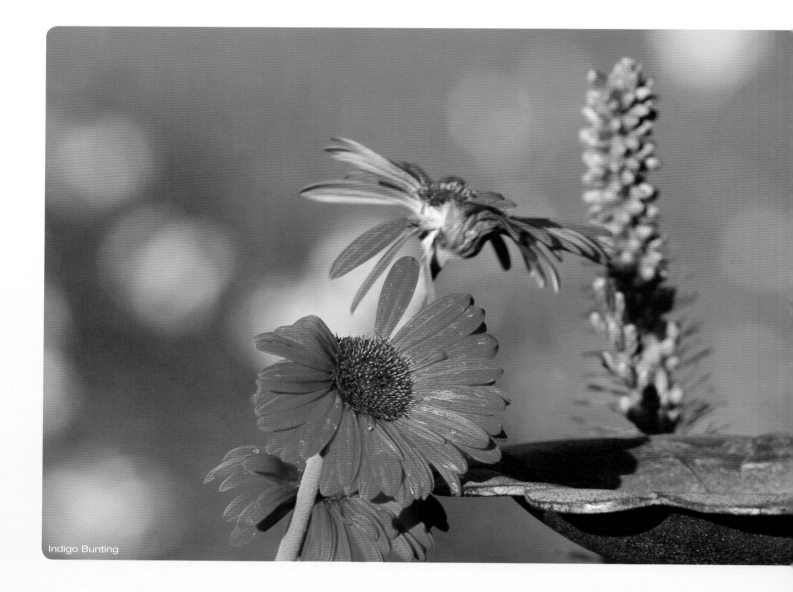
Indigo Bunting

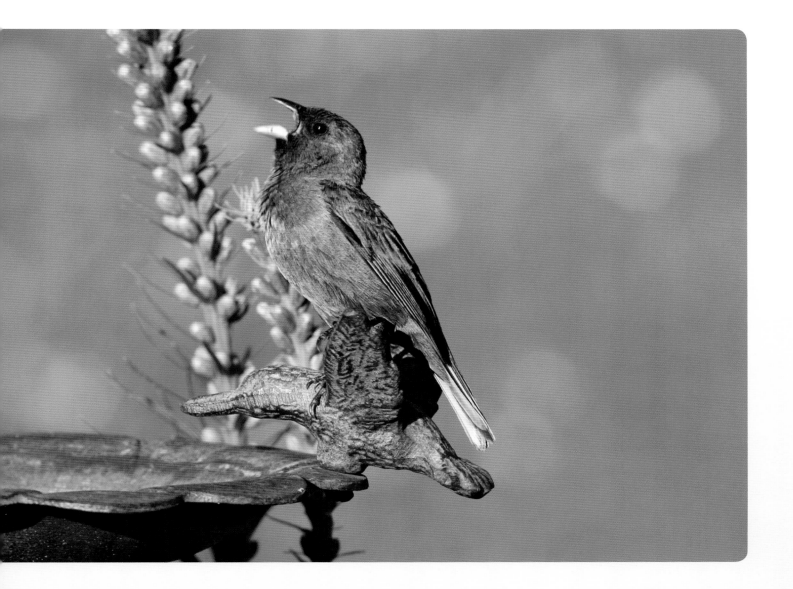

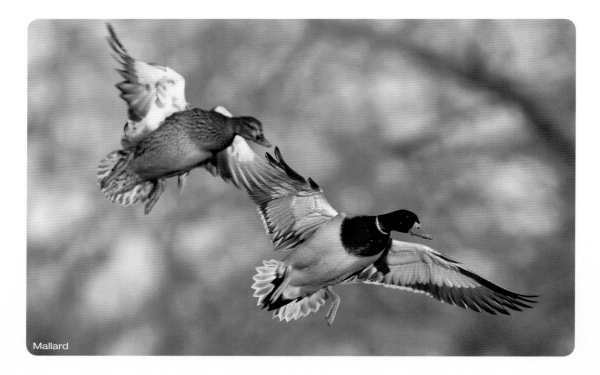

Mallard

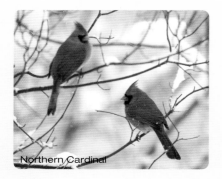

Northern Cardinal

IS IT A MALE OR FEMALE?

Many of our adult backyard species have different male and female plumages. This difference in coloration is called sexual dichromatism. When the males and females of a species have a different size, shape and color, it's called sexual dimorphism. In most of the bird world, the males are all dressed up and the females wear the duller attire.

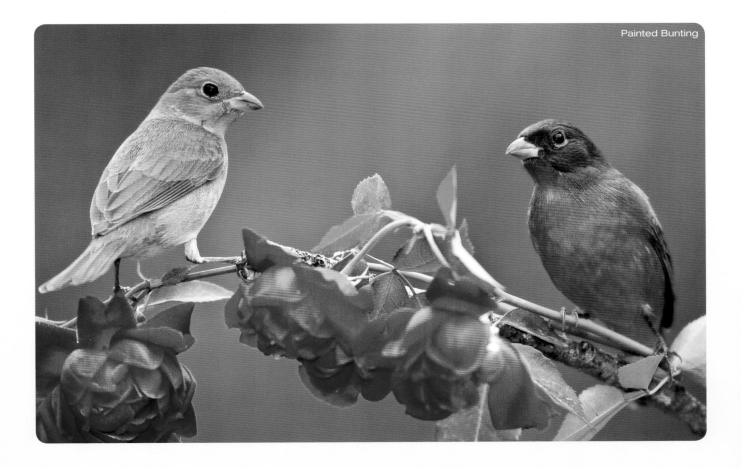

Birds are visual creatures and use their feathers to convey sexual maturity and readiness. The brilliance of the male's feathers is based on age, habitat, diet and other factors. Consider the brightly colored male Baltimore Oriole and American Goldfinch. Females see the males' breeding plumage in full color, and by their response, it obviously impresses them.

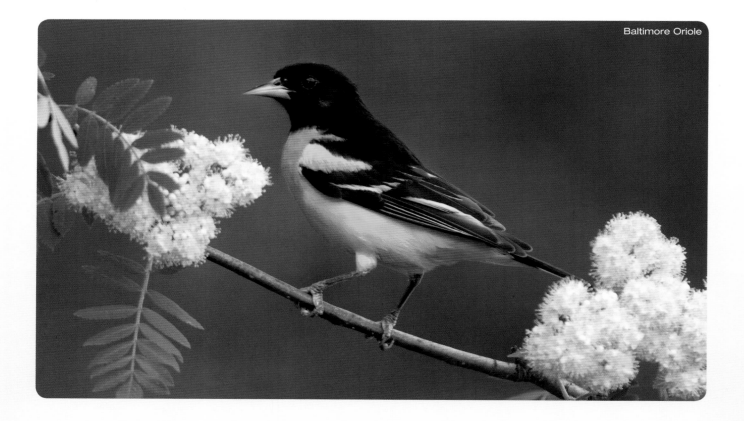

Baltimore Oriole

Male Rose-breasted Grosbeaks have a large, rosy red patch on their chests. This patch varies in size and shape among individuals. Size and color intensity combined most likely convey a strong message to females about a male's reproductive vigor. Presumably the larger and brighter the patch, the better the male will be as a mate.

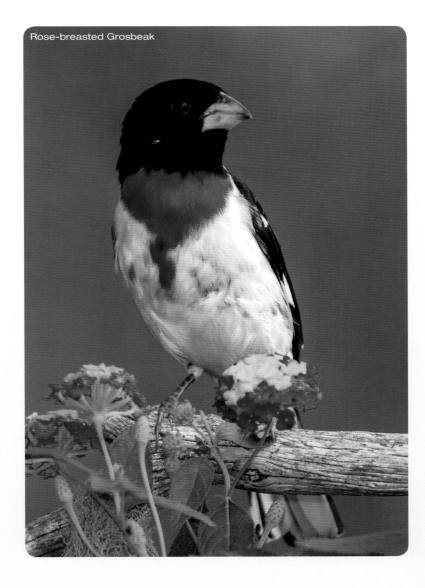

Rose-breasted Grosbeak

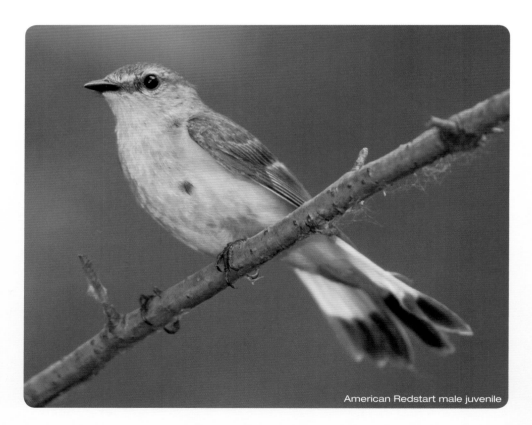

American Redstart male juvenile

JUVENILE PLUMAGES

With the exception of most woodpecker species, most of our juvenile backyard birds look very different from their parents. Young males that aren't yet breeding are often not brightly colored. After all, there's no reason to be advertising if you're not open for business!

All of our small backyard birds become ready to mate in their first year of life and nearly all obtain adult plumage during the first year. Exceptions include the American Redstart, a warbler that often takes a couple of years before the males develop their striking black and orange colors. Male Baltimore Orioles don't obtain their solid-black feathered heads until they are almost 5 years of age.

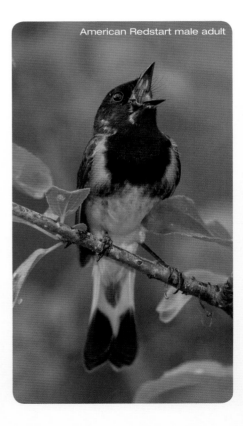

American Redstart male adult

KEEN EYESIGHT

Eyesight plays a tremendous role in the lives of backyard birds. They use their eyes not only to find most of their food, but also to navigate a forest or a backyard filled with innumerable twigs and branches. They keep a sharp eye out for predators on the ground and in the sky, and they use sight to consider a mate. Without sight, the birds would be unable to gather nesting material, weave a nest or fly, and would quickly die.

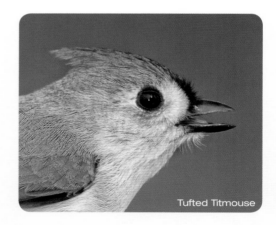

Tufted Titmouse

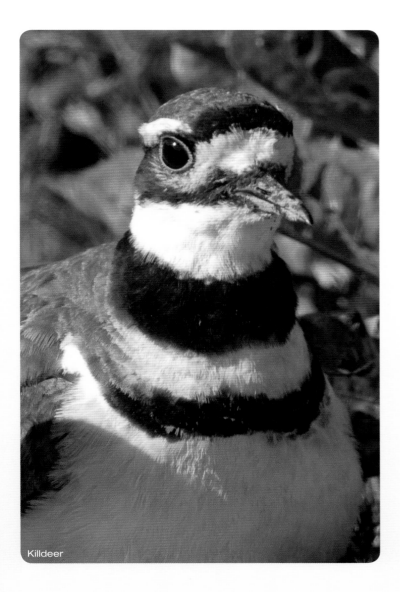

Killdeer

29

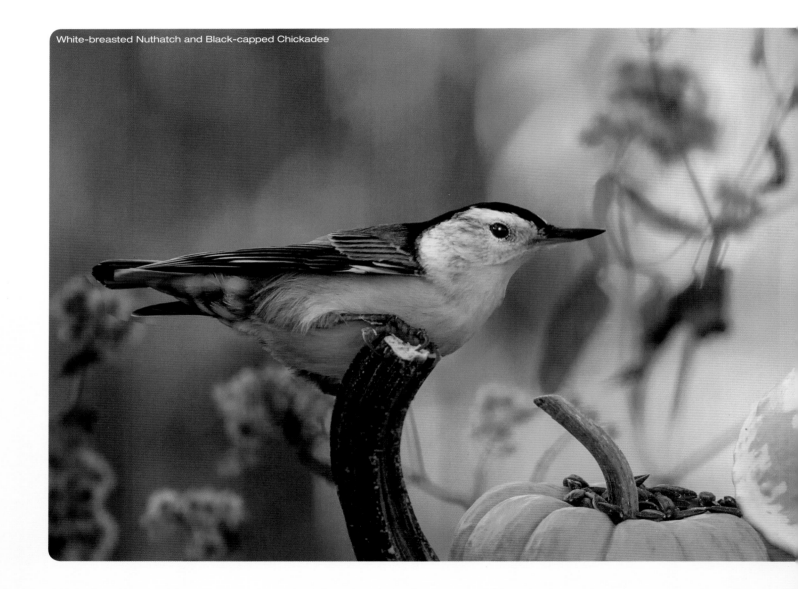

White-breasted Nuthatch and Black-capped Chickadee

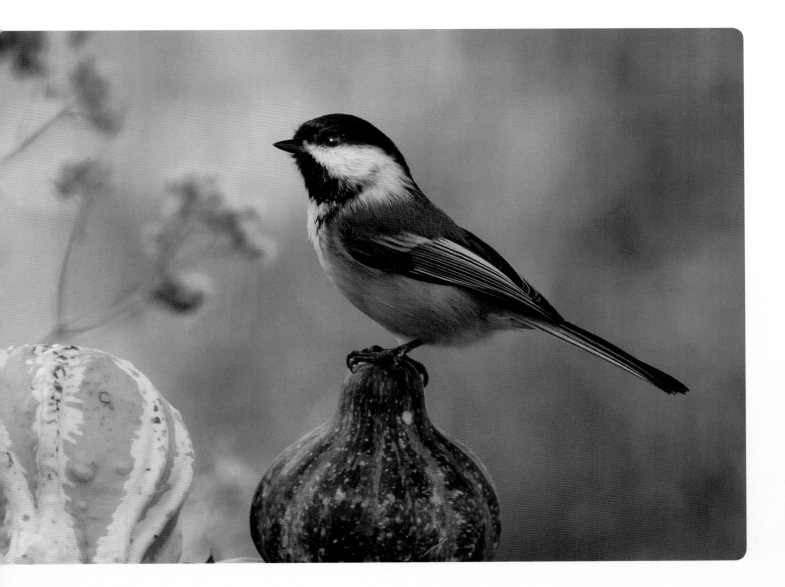

KNEE AND ANKLE—OR FOOT?

I am often asked why a bird's knees bend backward. If you look at the legs of a typical backyard bird, it does look like the knees point backward. However, what you are seeing is actually the bird's ankle. The knee is hidden up in the feathers near the body.

Birds walk around on their toes—not on flat feet, like many mammals. So the length coming up from the toes is the foot, and the joint that looks like a backward knee is actually the bird's ankle.

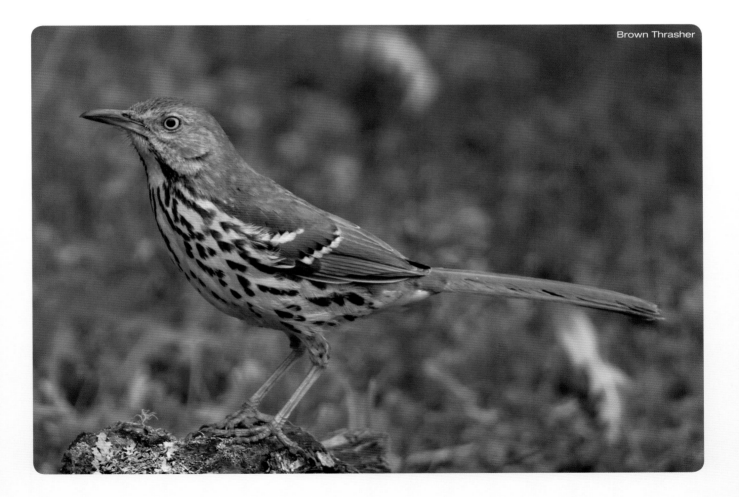

Brown Thrasher

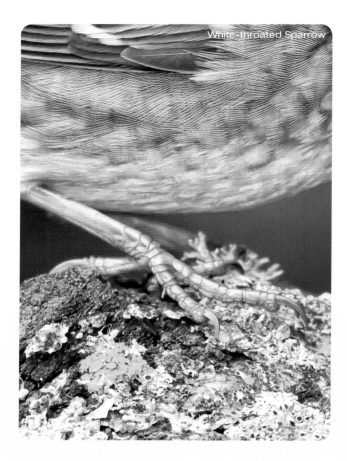

White-throated Sparrow

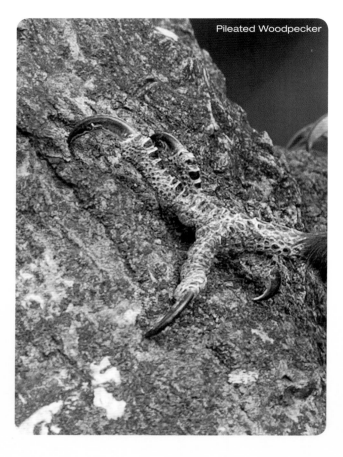

Pileated Woodpecker

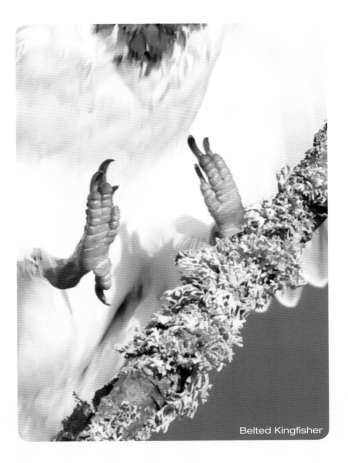
Belted Kingfisher

TOE ARRANGEMENTS

Like other birds, a woodpecker's feet and toes are covered with overlapping horny plates called scutella. Most of our backyard birds have four toes: three point forward and the fourth points back. The hind toe, known as the hallux, is usually smaller or shorter than the others.

Woodpeckers, however, have a different toe arrangement. They have two toes pointing forward and two back. This unique toe arrangement, called zygodactyl, helps them defy gravity and cling to trees without slipping.

Toes are often modified in many ways to help birds hunt, climb trees or perform other daily activities. Belted Kingfishers, for example, have two toes that are fused together. It is thought that the fusion helps when the birds are digging their nearly 6-foot-long tunnels in dirt banks for nesting.

Some of our backyard visitors have unique physical attributes, while others have specialized behaviors. The White-breasted Nuthatch is called the upside down bird because it's known for hitching down tree trunks headfirst. This is unlike most other tree climbers, which hike up trunks. This chunky little bird accomplishes this feat with an extra-long claw on its hind toe. The large curved nail helps the bird hold on tight as it moves around, defying gravity.

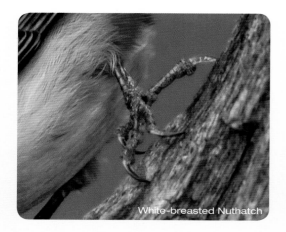

White-breasted Nuthatch

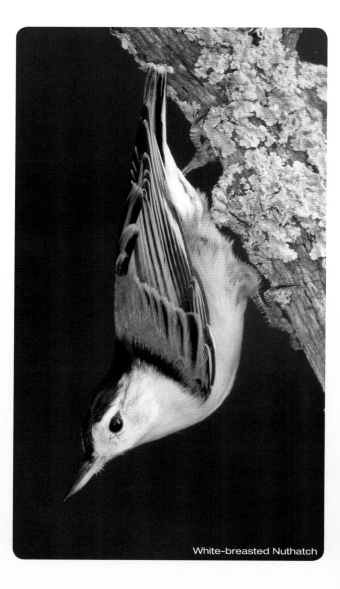

White-breasted Nuthatch

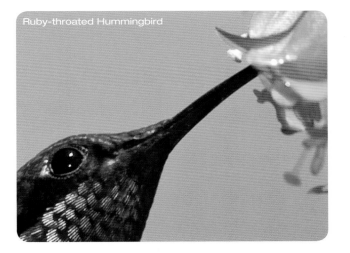

Ruby-throated Hummingbird

Birds have a wide variety of other anatomical adaptations, more so than other animals. These are usually seen in the bill and also the digestive system, because both relate to food.

For example, a bird's beak is often highly modified to maximize its efficiency in gathering specific foods. A hummingbird's bill is long and narrow for reaching deeply into tube flowers. A cardinal's bill is short and heavy for cracking open sunflower seeds. A crossbill's beak is uniquely crossed to extract seeds from coniferous cones, its main diet item.

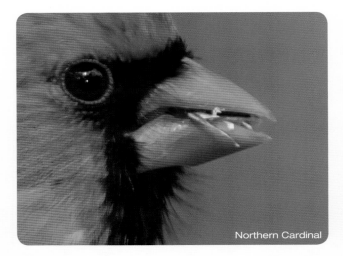

Northern Cardinal

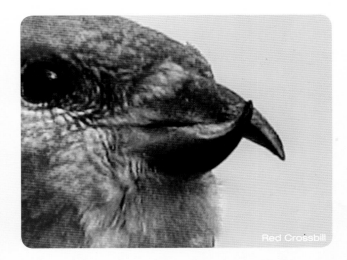

Red Crossbill

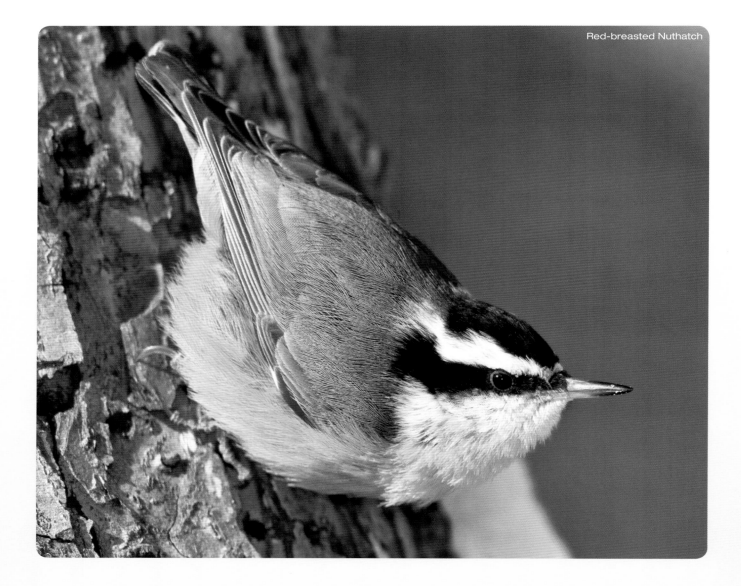

SEASONAL FEEDING

Backyard birds feed on a wide variety of food items. Most are food specialists and concentrate all of their food-gathering efforts on specific types of food. In addition, most birds are seasonal feeders, concentrating on specific foods at certain times of the year. For example, White-breasted and Red-breasted Nuthatches spend a lot of time searching for insect egg sacs during winter. In regions where seasonal temperatures dip below freezing, insects lay thousands of eggs that can survive the cold and hatch in spring, while the adults die. Many insects lay a sac filled with tiny eggs, which is like a full course meal for nuthatches and other backyard birds.

Starting in fall and continuing into winter, the nuthatch diet is about 70 percent seeds, nuts and other plant-based foods. Most studies show that backyard birds derive only about 20–25 percent of their diet from feeders, so providing seeds is just a supplement for nuthatches and many other species.

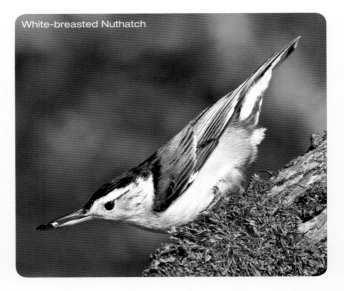

White-breasted Nuthatch

During spring and summer, some species dine nearly entirely on insects. Northern Cardinals feed their babies a complete protein-packed diet of insects, as do Blue Jays and Rose-breasted Grosbeaks. Parents set out to find and gather as many insects as possible. If they find smaller insects, they stack them in the corners of their beaks before distributing them to the waiting chicks. When they find one large insect, they rush back to deliver the meal.

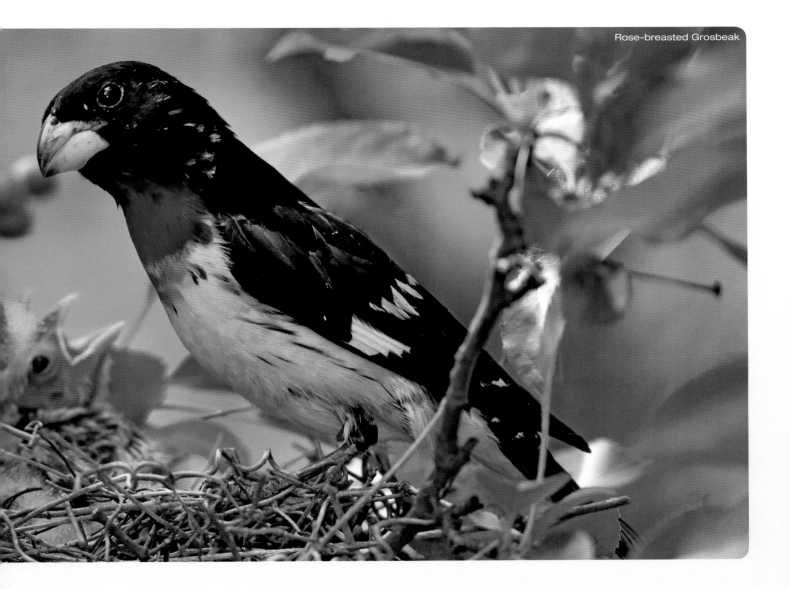

A nuthatch will usually snatch a seed and retreat to the safety of a tree. Once there, it wedges the seed in a crevice and whacks it open with its long, pointed bill while using its long-clawed hind toe as an antigravity device. This is how nuthatches got their common name—by hatching open seeds. Unlike nuthatches, chickadees hold their seed with their toes while hammering it open.

Northern Cardinals are heavy seedeaters during fall and winter. They crack seeds open with their powerful, oversized bill. They often sit at feeders, cracking seed after seed, manipulating the seed to stand it on its side before crushing the hard outer shell. To extract the nutmeat inside, they use their tongue.

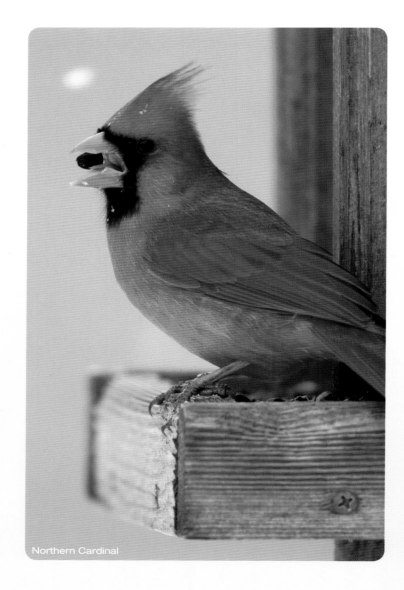

Northern Cardinal

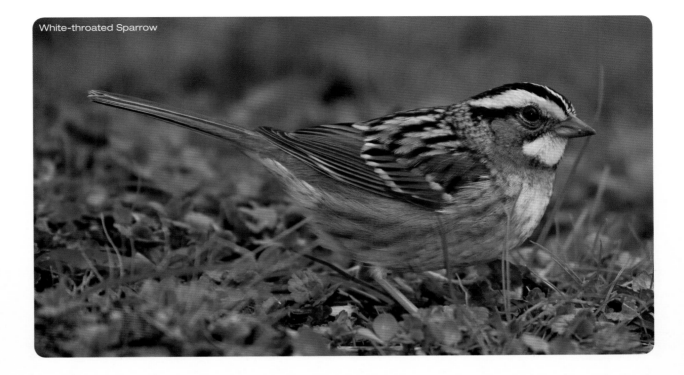
White-throated Sparrow

Many of the ground-feeding birds, such as White-throated and White-crowned Sparrows, use a method of hopping backward twice with both feet to scratch around on the ground. When a seed is exposed, they make quick work of cracking it open with their short bill and consume the nutritious nutmeat within.

By most surveys, tens of millions of Americans feed birds in their backyards. These surveys suggest that more than 60 million Americans (20 percent of the population) feed birds. This is greater than the combined number of people who play the three major sports in America—basketball, baseball and football!

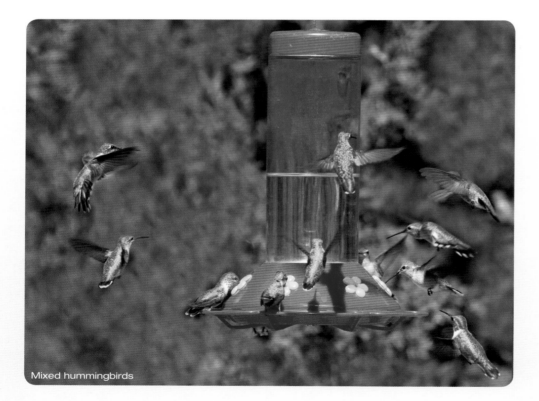

Mixed hummingbirds

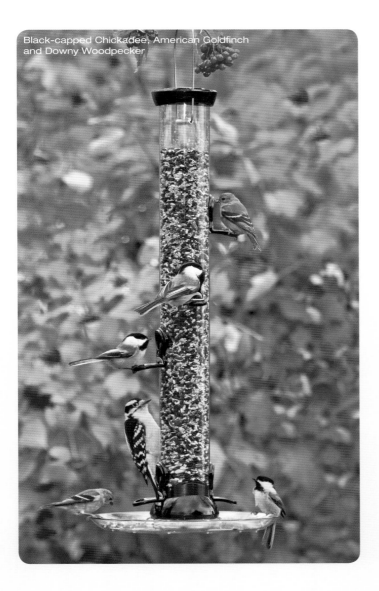
Black-capped Chickadee, American Goldfinch and Downy Woodpecker

A few surveys asked Americans why they feed birds. Over 80 percent said they wanted to draw the beauty of nature closer to their own yards. Others said they liked the fun of seeing birds, and a small percentage said they wanted to help the birds with extra food offerings. About two-thirds of the respondents were women and over half were above age 45. Most had been feeding birds for more than 15 years. Some reported that feeding birds was therapeutic, while others felt it was educational.

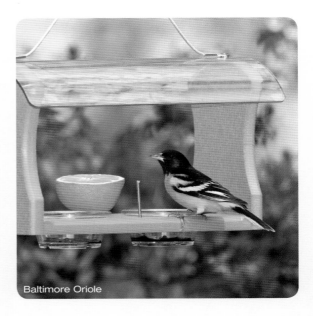
Baltimore Oriole

No matter how much you feed the birds, they won't become dependent on your food supply. Birds have wings, and they know how to use them! They will continue to forage for wild food even though your feeder may be full. When your feeder runs dry, they simply search for food in the wild like they did before you started feeding them.

Studies about bird feeding show a generally positive impact on birds that visit feeders under certain conditions. Some conclude that backyard bird feeding can help the overall survival of birds only during the coldest and snowiest winters. In general, during the coldest and snowiest winters, birds with regular access to food had a higher survival rate (69 percent) than those without (37 percent). These birds were in better condition in spring and a few species had increased nesting success also. The study also suggested that during normal-weather winters, there was not much advantage.

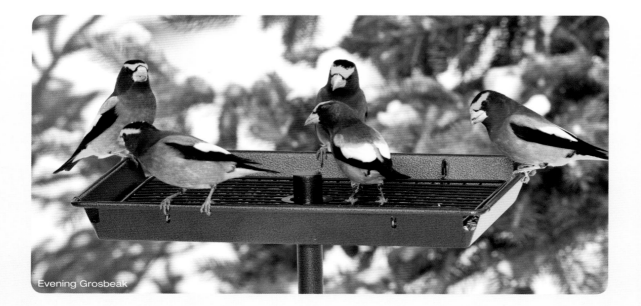

Evening Grosbeak

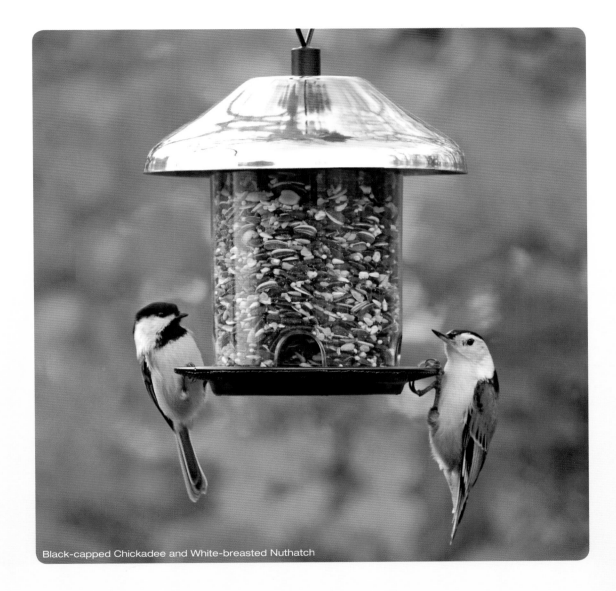

Black-capped Chickadee and White-breasted Nuthatch

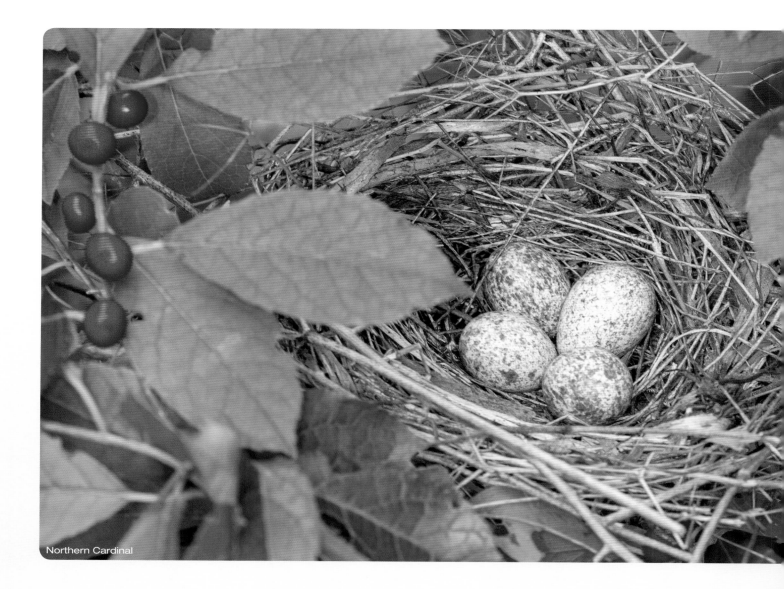

Northern Cardinal

Other species had a drop in reproduction in spring. Some suggested that an unbalanced diet was the cause, because a diet too high in fat leads to decreased egg production in spring.

Sometimes feeding birds attracts large numbers of birds to one spot in your backyard. Small raptors, such as Sharp-shinned and Cooper's Hawks, are carnivores and will hunt in yards with feeders for their next bird meal. Birds of prey hunt birds that are weak, young or old, and feed on injured birds as well, and they are absolutely essential for keeping our backyard bird populations healthy and strong.

FRUIT DIET APPEARANCE

Cedar Waxwings are frugivorous birds, feeding on about 70 percent fruit. The red spots on their wings are pigmented extensions of the feather shafts, and the red color comes from a carotenoid pigment found mainly in red fruit. Thus, the red wing tips are one result of the bird's diet. The yellow band at the end of the waxwing's tail also coincides with the bird's food. Studies show that the red wing markings are also related to the bird's age, and they advertise the breeding status.

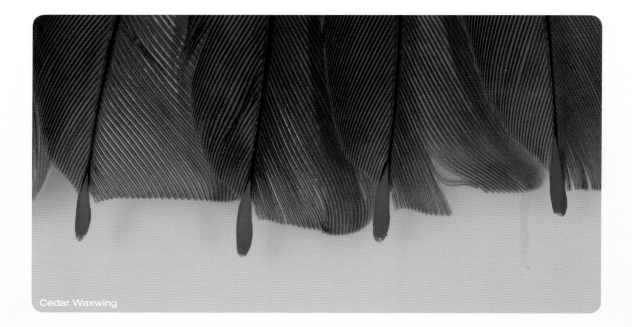

Cedar Waxwing

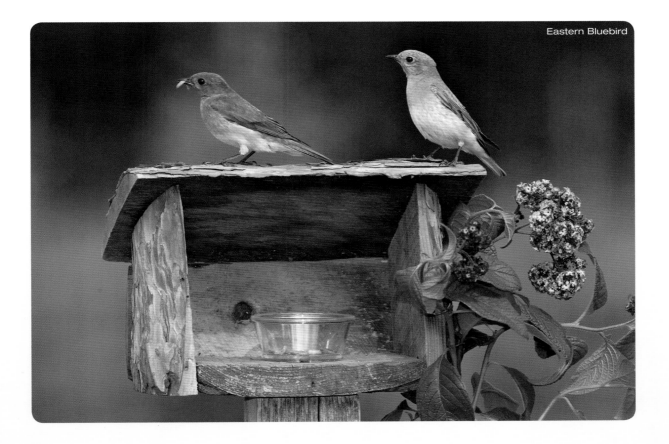

Eastern Bluebird

INSECT DIET

Eastern Bluebirds will come to small trays offering mealworms,
which are high in fat and protein. Many homeowners enjoy
feeding these wonderful birds this way.

Northern Cardinal

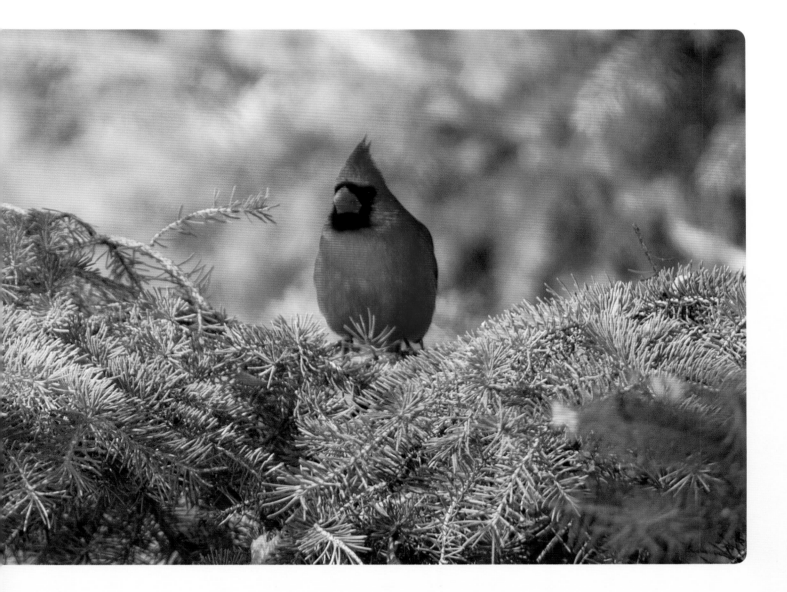

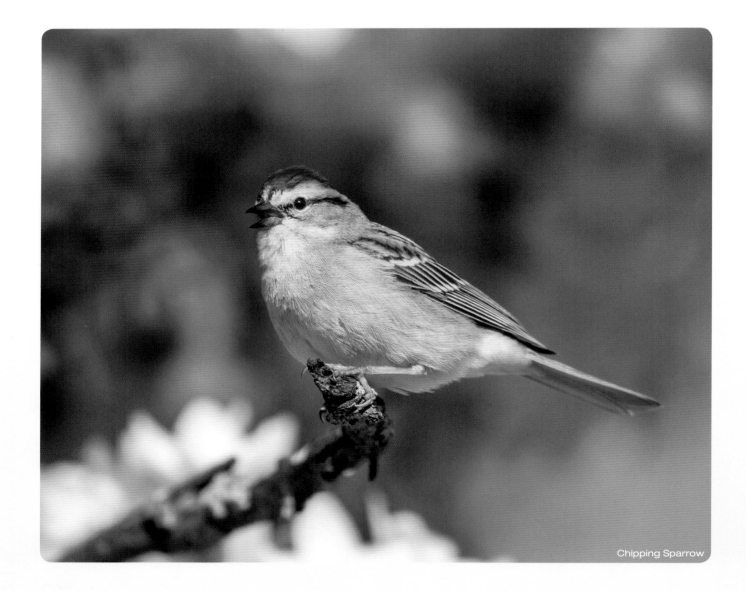

Chipping Sparrow

Most of our backyard birds communicate with beautiful songs. Others use rudimentary chips and clicks. Step into your backyard on any spring morning to hear this wonderful natural music for yourself.

Bird songs are not basic tunes that are sung for only one reason. No, bird songs are complicated, even when they sound simple to our ears. Just because we don't understand the "words" of the songs doesn't make them less complex.

To our ears, many birds seem to have one basic song. However, from sophisticated sonograms we know that many of these songs have all sorts of variations. Often a small phrase of the song, called a micro verse, changes. Studies show that males with a wide variety of micro verses in their songs attract more mates and hold the best territories.

Other birds, such as the Chipping Sparrow—a common backyard bird in most of the United States and Canada—have one simple song. The male perches up high and belts out a rapid chip note over and over. His song can be heard at great distances and evidently tells other males that he owns the territory. It also lets the females know that he's available for mating.

Some birds have a set repertoire of songs, with a small variety used for apparently different purposes. The Northern Mockingbird, common in many regions of the country, sings with its beak closed and has about 150 different kinds of songs, many of which are copied from neighboring birds. A wonderful man I know once said, "If you have a mockingbird in your yard, you don't need any other birds." When you listen to a mockingbird, you can hear phrases and songs imitated from a wide variety of other species.

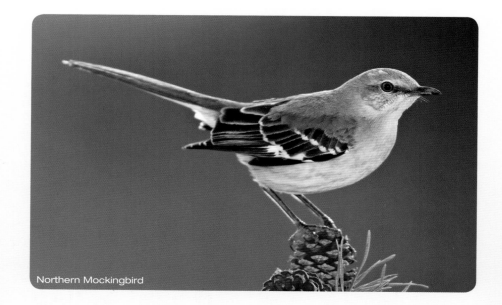

Northern Mockingbird

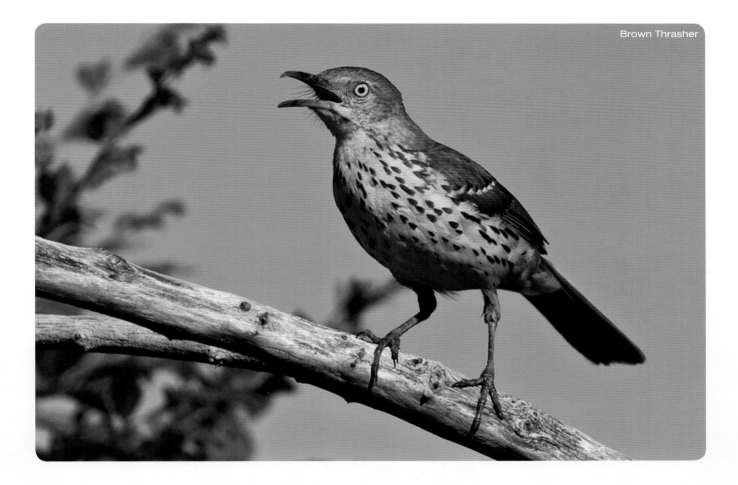

The master of bird songs, however, is the Brown Thrasher. This rather plain-looking, rusty brown bird with a long tail sings more than 1,100 different songs. It perches in thick bushes and belts out loud, clear songs, repeating each phrase twice.

TWO-SONG MULTITASKERS

If that is not enough, the Brown Thrasher is capable of singing two songs at the same time! Like many other birds, it has a two-sided organ called a syrinx (similar to our windpipe or trachea), located where the trachea divides into two tubes (bronchi) that lead into the lungs. Half of the syrinx rests in each bronchi and each half can make sounds independently. This enables the bird to sing two different notes simultaneously, even though our ears only hear one song.

Many other birds also have this capability. Some alternate between the syrinxes independently, producing a rich, wonderful sound. It's often compared to a piano player using two hands independently to produce one smooth sound.

It is said that birds use 100 percent of the air they expel to produce songs. The mouth and beak play a much smaller role in formulating a bird's song. This explains why birds can sing complete songs when holding insects or nesting material in their beaks, or in some species, such as the American Robin and Northern Mockingbird, without opening the beak at all.

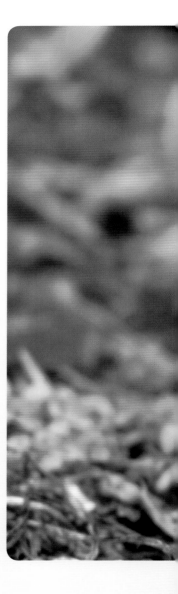

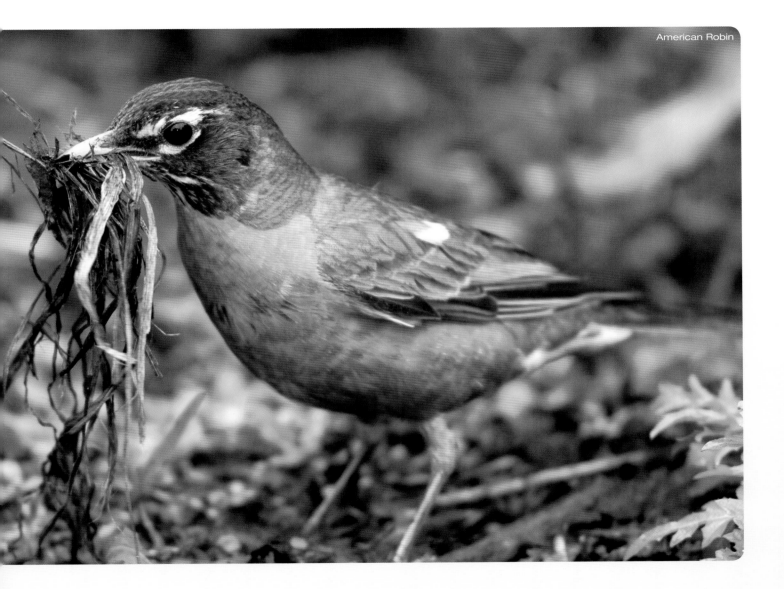
American Robin

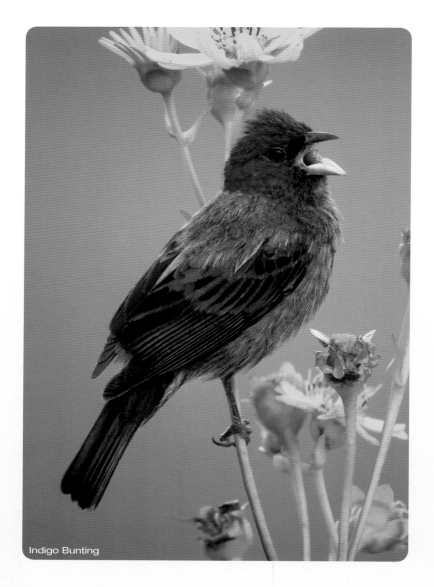
Indigo Bunting

If you watch birds singing, you may have noticed that it's mainly the males that do the serenading. Male Indigo Buntings are prolific singers. In late spring and early summer, the male will belt out his song, repeating it up to 200 times an hour throughout the day. Each sound in a phrase is repeated once: "What, what! Where, where! See, see!" Young males learn songs by listening to their fathers and other males. This produces great variation in the songs.

Gray Catbirds are fun flutists. The males are well known for their variety of sounds in addition to songs. They string together a number of musical phrases, along with strange and unusual sounds that include whistles, squeaks and more. These sounds are often repeated and interspersed with a call that sounds like a meowing cat, hence the common name.

Northern Cardinals and Northern Mockingbirds are classic exceptions to the general rule that the males are the only songsters. In these species, males and females often sing in duets, called counter-singing. The male sings his song, and the female sings an answer. Their songs sound alike to us, but there are differences among them, clearly evident in sonogram examinations.

Interestingly, the phenomenon that male birds are the songsters doesn't hold true outside of the United States and Canada. In tropical regions, where most birds occur, and most regions in the Old World, such as Europe, Africa and Asia, the females sing as much as the males. A remarkable 71 percent of all the birds in the world have females that sing. In the United States and Canada, the percentage is much smaller.

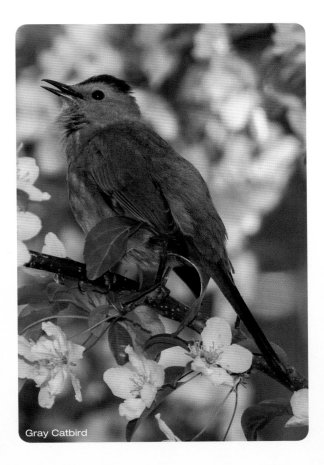
Gray Catbird

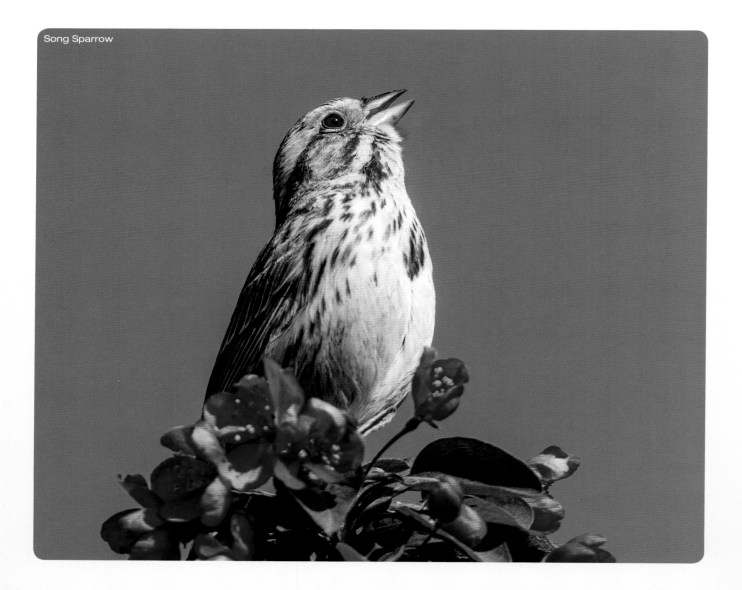
Song Sparrow

Did you know that some birds have regional dialects? That's right—some birds have accents just like people, depending on where they live. The classic example is the Song Sparrow. This small brown sparrow is common throughout the United States and most of Canada and sings a different song in different regions. The song always starts out with the same three notes, but the following trill is unique to the locale. All Song Sparrows in a given area sing the same kind of song, indicating they may be learning from each other.

POUNDING OUT DRUMBEATS

Some backyard birds don't sing at all. Woodpeckers, for example, communicate by drumming. In many species, both sexes drum. Usually the male finds a hollow branch or similar resonating object and drums on it rapidly. The Downy Woodpecker, for example, drums at a rate of 10–15 beats per second. The sound echoes through the home range to announce ownership. Drumming is often heard from greater distances as well.

Each woodpecker species has a different drumming cadence, making it easier to identify the bird. Most woodpeckers have a uniform drumming cadence. Sapsuckers have an irregular drumbeat, making them easy to distinguish from other woodpeckers.

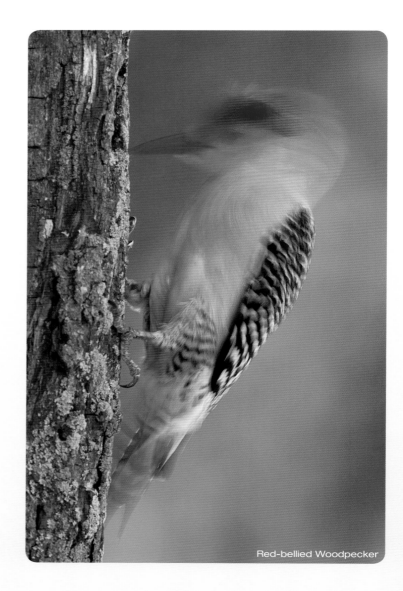

Red-bellied Woodpecker

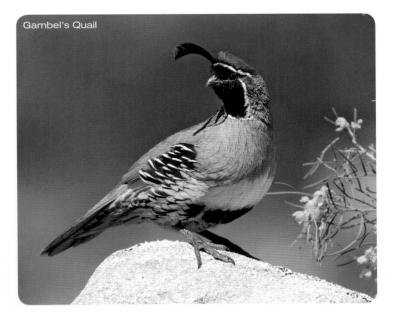

Gambel's Quail

SINGING IN SEASON

Some birds sing or call throughout the year. The Gambel's Quail, a familiar backyard bird in parts of the Southwest, gives a unique call all year long. Black-capped and Carolina Chickadees vocalize year-round but sing specific songs in spring. Other birds, such as Rose-breasted Grosbeaks, sing only in spring.

Generally, backyard birds that sing do it to advertise their sexual readiness. In many species the male's health is partially judged by the strength of his song. In other species, females evaluate males to mate by their repertoire or the complexity of their songs. Males that sing to proclaim a territory are often broadcasting to neighboring males not to enter the area. Since most birds nest only in spring, this is when most of the songs are heard.

ADJUSTING SONGS TO THE HABITAT

Birds adjust their songs to the acoustics of the habitat.
Vegetation in dense habitat, such as a coniferous forest,
scatters and absorbs high-frequency sounds. Birds in
these types of habitats give low-frequency sounds.
In open habitats, such as prairies, birds often have
high-frequency songs that can be heard farther away.

Recently it's been discovered that birds in noisy cities
increase the volume of their songs and sing more during
late evenings and nights, avoiding the noisiest parts of
the day. Many studies show that birds living in urban
environments sing louder when compared to their
rural cousins.

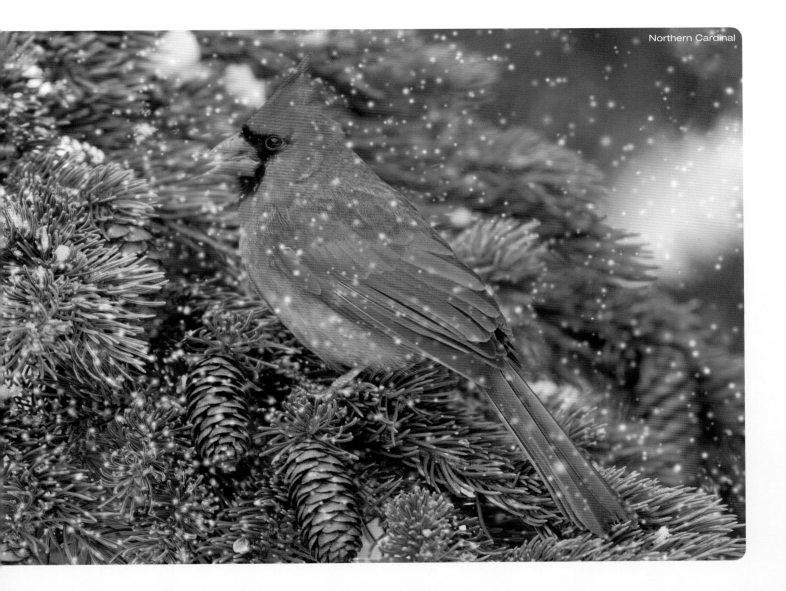

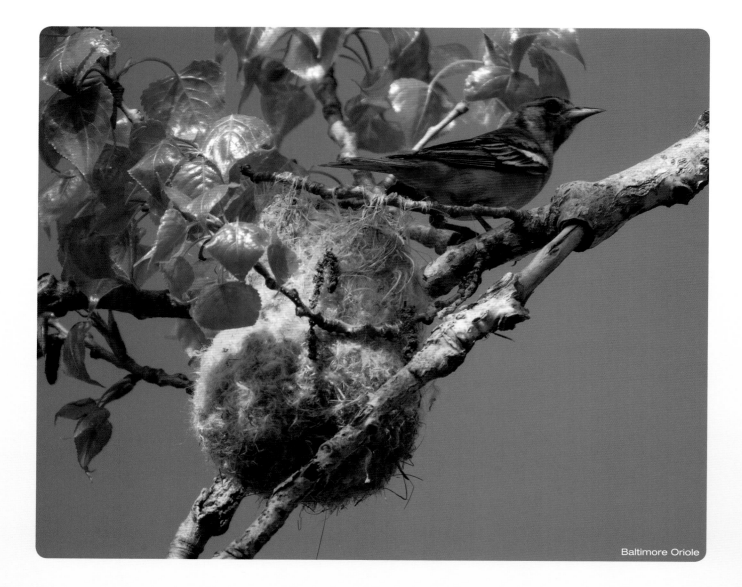

Baltimore Oriole

Bird nests are about as diverse as the birds that construct them. Nests vary in size, shape, building material and design. Some are simple, while others are extremely complicated. Some take little time to build; others are refurbished year after year and used for many generations! Equally amazing is the fact that some birds don't bother to use a nest at all.

Nests are placed in a wide variety of locations, from the branches of a tree to edges of mountaintops. Some nests just sit on the ground, while others are underground. Most backyard birds construct woven nests of dried plant material. Baltimore Orioles are the best weavers, building some of the most intricate nests, which hang from the far reaches of tree limbs.

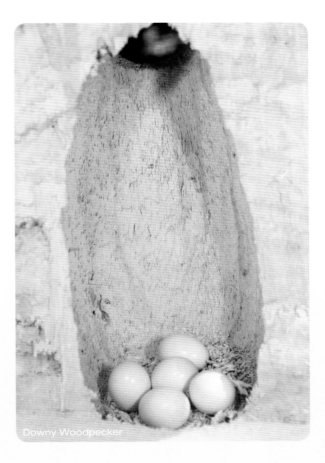

Downy Woodpecker

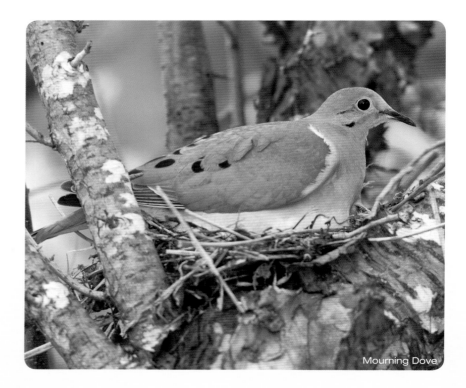
Mourning Dove

THE NO-FUSS HOME

Mourning Doves, backyard nesters found across the United States and parts of Canada, often build their nests low to the ground. These shy, grayish brown birds assemble a small amount of twigs and sticks and arrange them in a flimsy platform to balance two unmarked white eggs. Unfortunately, the nest often falls apart in a strong wind, and the eggs or chicks end up on the ground. How these birds survive is a mystery to me, but judging by their numbers, they do just fine.

Days before the baby Mourning Doves hatch, both parents start producing a milk-like liquid in their gullet, called crop milk. Crop milk is very nutritious, containing 25–30 percent fat and 10–15 percent protein. It allows the hatchlings to grow quickly and leave the nest after just one week.

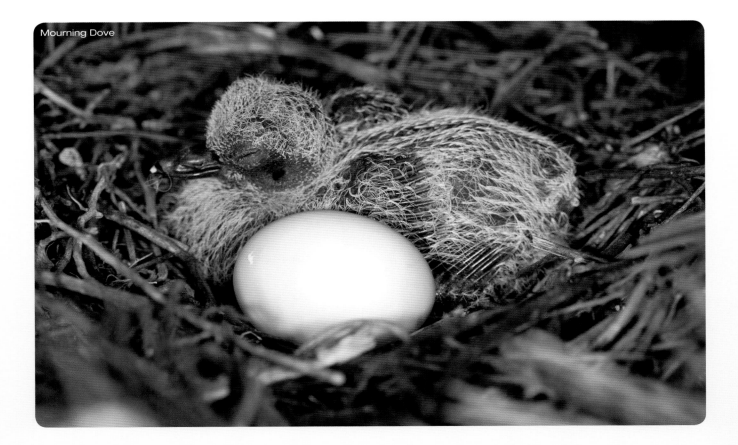

Mourning Dove

CAVITY NESTING

Black-capped and Carolina Chickadees make cup nests inside natural cavities or man-made nest boxes. What's interesting about these nests is that the base is always constructed with green moss. The lining of the cup is usually soft with fuzzy animal hair.

Nuthatches usually nest in natural cavities that they don't excavate themselves. Both parents collect fine, soft plant materials, along with feathers and fur, to create a comfortable interior. After the babies hatch, the parents are extremely busy, filling their beaks with insects to feed to the begging young. Once the babies eat, they quickly turn around and expel a fecal sac. The parents grab the waste and fly off to deposit it away from the nest.

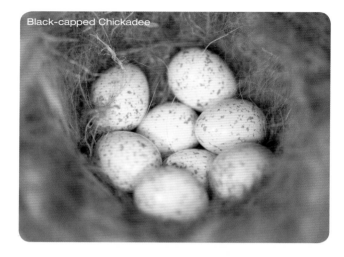
Black-capped Chickadee

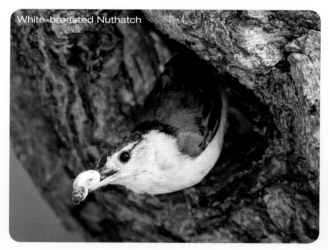
White-breasted Nuthatch

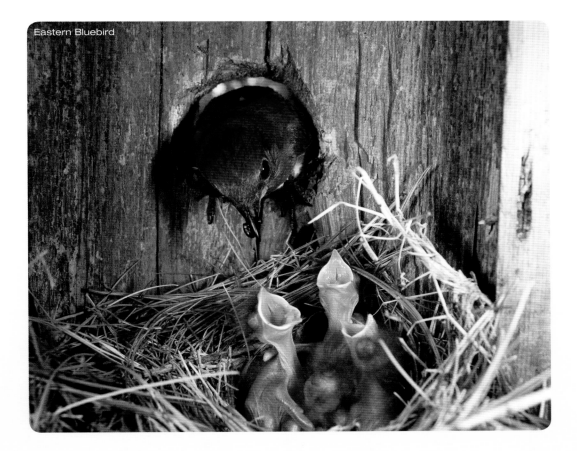

Eastern Bluebird

Some of us are lucky enough to have woodpeckers excavating nest cavities in our backyards. Early in spring, the male and female work in tandem to chisel out a cavity just large enough to raise their entire family. Most woodpeckers excavate in dead branches—rarely in live wood. Once they use a cavity, they rarely come back to reuse it. This leaves cavity vacancies that Eastern Bluebirds, Tufted Titmice and many other bird species quickly fill. Nest boxes make choice homes for these birds as well.

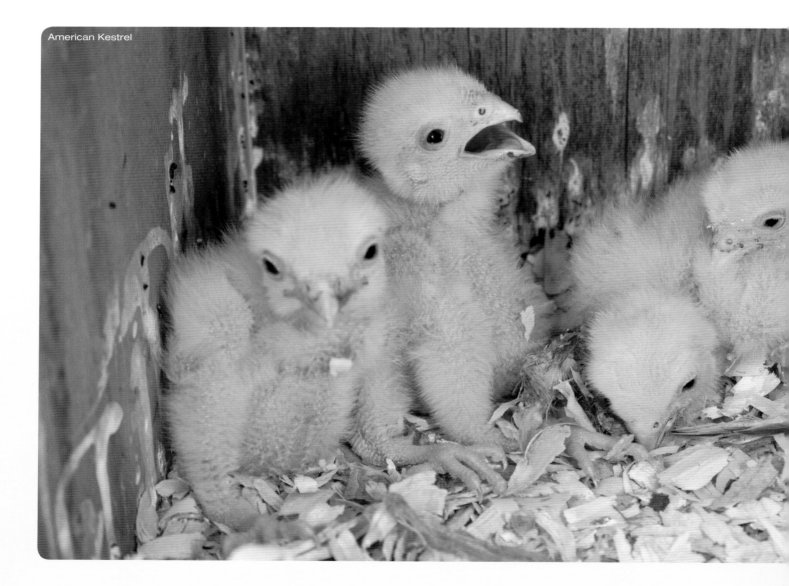

American Kestrel

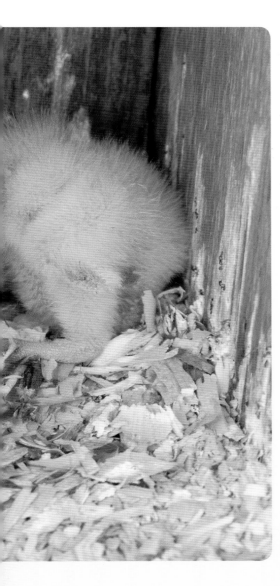

Some people are fortunate to have a large, open field for a backyard. A well-placed nest box for American Kestrels can attract these small falcons to your yard. It's easy to tell the difference between the boldly colored males and duller females—something that's not very common in raptors.

A kestrel won't build a nest inside the box; it just lays eggs on the woodchips within and begins to incubate. Babies hatch in about 30 days. This is when things get interesting, because the parents start to bring in food on a regular basis.

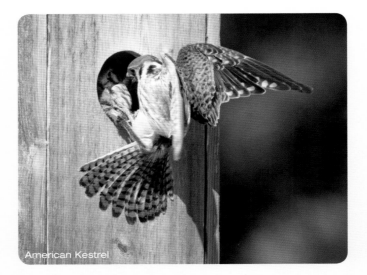

American Kestrel

SWIFTS IN CHIMNEYS

Our Chimney Swifts are fascinating birds—although it might be a stretch to say they are backyard birds. They are more like above-the-backyard birds. Chimney Swifts are small brown birds that spend their entire day flying and catching insects. Rarely do they land. Families stay together, which results in four or more adult birds taking care of a nest full of babies.

Chimney Swifts nest in chimneys, hence their common name. They build their nests with small sticks and attach them to a chimney's interior wall. Interestingly, they use their saliva to glue the nest to the wall and keep the nest together. The parents fly down to the nest, but they must use their special sharp claws to scale the chimney when it comes time to leave. Before chimneys were prevalent, these birds nested in hollow trees.

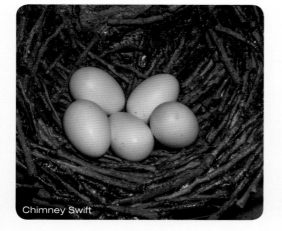

Chimney Swift

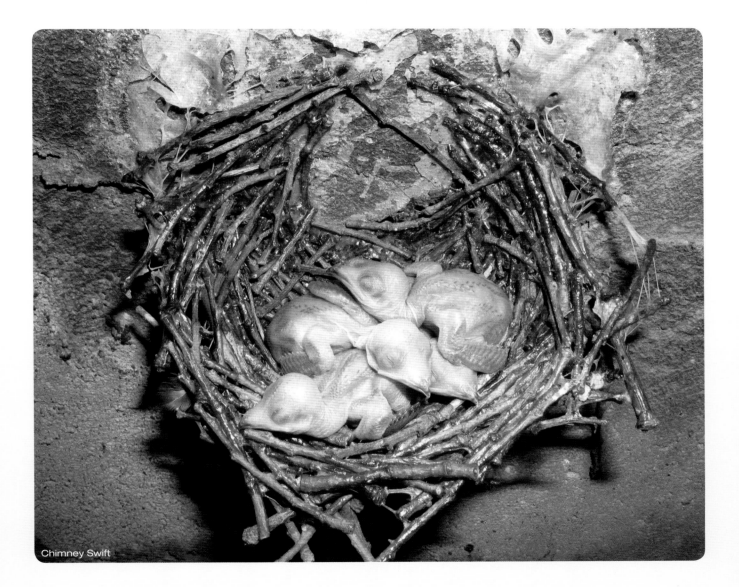
Chimney Swift

77

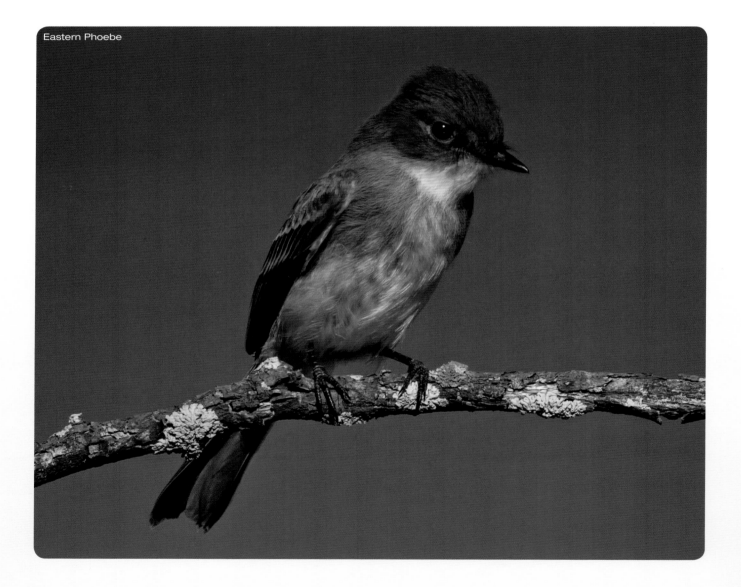

Eastern Phoebe

Not all backyard birds come to feeders or birdbaths. Eastern Phoebes are one of these common birds, often nesting on sheds, barns and houses. These drab-colored birds construct open cup nests mainly with green moss, similar to Black-capped Chickadees. They build nests on a shelf with a roof or other shelter to keep out rain. Sometimes they build on top of Barn Swallow nests. Phoebes build more than one nest and then choose the best one to raise their young.

Eastern Phoebes are very vocal in early spring, but they fall silent after nesting begins. As flycatcher family members, their diet is about 90 percent insects and spiders. These are marvelous birds to have in your backyard to help keep insect populations in check.

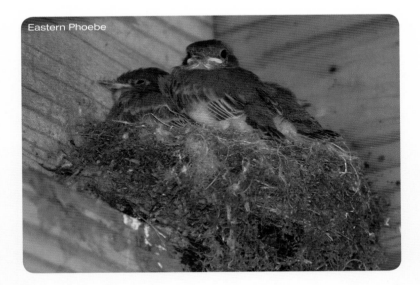

Eastern Phoebe

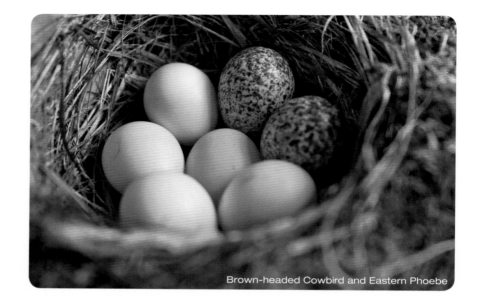

Brown-headed Cowbird and Eastern Phoebe

PARASITIC NESTING BIRDS

In North America, all birds build some kind of nest to raise their young, except for cowbirds. Brown-headed and Bronzed Cowbirds are known as parasitic nesting birds. This means they don't build their own nest. After mating, the female cowbird searches for the nests of other birds and waits until the mother leaves or bullies her way into the nest to deposit her speckled egg. The entire egg-laying process for female cowbirds goes quickly, lasting just seconds in some cases. She flees promptly, leaving the host parents to perform the incubation and raise her young.

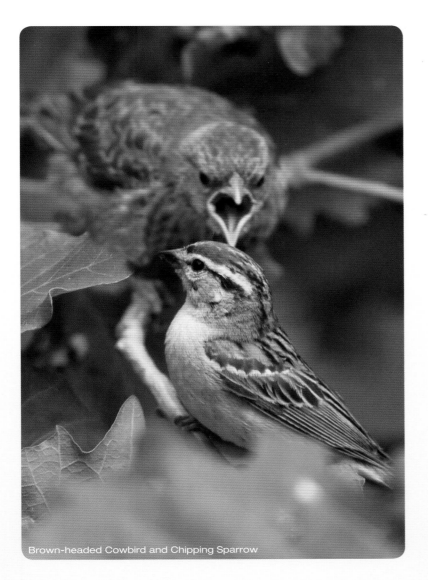
Brown-headed Cowbird and Chipping Sparrow

About 200 species of backyard birds accept the cowbird egg. Many other species eject the cowbird egg, abandon the nest, or build another nest over the top of the one with the cowbird egg. When the egg is accepted and the cowbird hatches, it sometimes pushes the other eggs out of the nest or competes with the host babies for all the food.

People who have large, open yards with gravel driveways or paths are familiar with Killdeer. These shorebirds don't nest at the shore and are mostly known for their loud, plaintive "killdeer" call. Classic ground nesters, their nests consist of a shallow scrape, usually in gravel. The mother lays four heavily spotted eggs in the depression; when she isn't on the nest, the eggs are nearly impossible to see. Adults have two black bands on their necks that help break up their silhouettes, making them harder to see during their 24–28 days of incubation duty.

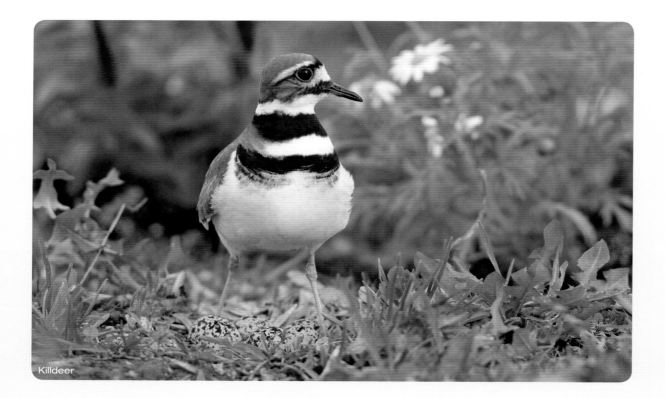

Killdeer

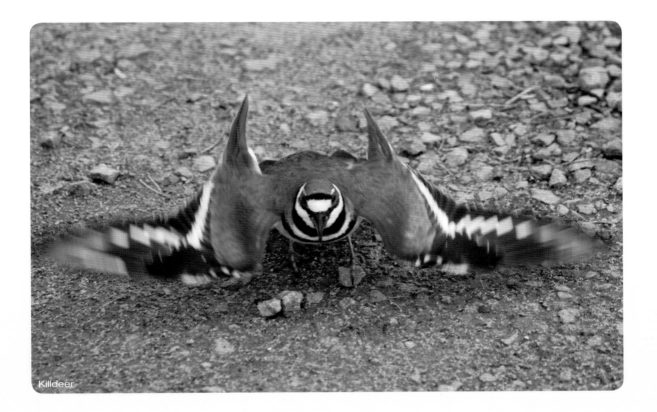

Killdeer

Killdeer are famous for their broken wing distraction display to draw predators or people away from their nests. When an intruder comes close, the parents approach it and pretend to have a broken wing while slowly moving away from the nest. If the threat doesn't follow them, the adults fly closer and give much louder calls to get the predator's attention. When they're successful at drawing the danger away from the nest site, the adults suddenly take flight, leaving the intruder behind.

BLACKBIRD APPRECIATION

One of the more maligned backyard birds is the Common Grackle, but this blackbird family member is unique in many ways. Grackles strut across your lawn in a highly stylized fashion. Their long tails point slightly upward to keep from dragging in the grass. Interestingly, male grackles fold or crease their tails lengthwise in a V shape when in flight, forming a keel. They sometimes nest in large colonies of upwards of 20 pairs in a couple of close evergreen trees with dense cover.

Grackles are some of the more interesting birds when it comes to observable behaviors. When two or more grackles gather at a location, one will approach another with its head in the air and its bill pointed toward the sky. This behavior, called billing, is often a sign of aggression or dominance. It is usually accompanied by waving the bill around in exaggerated motions.

Boat-tailed Grackle

They will also grab ants from anthills in your yard, partially crushing the ants, which releases the ants' natural defense—formic acid. Grackles wipe or rub the ant over their feathers, which is said to help condition plumage.

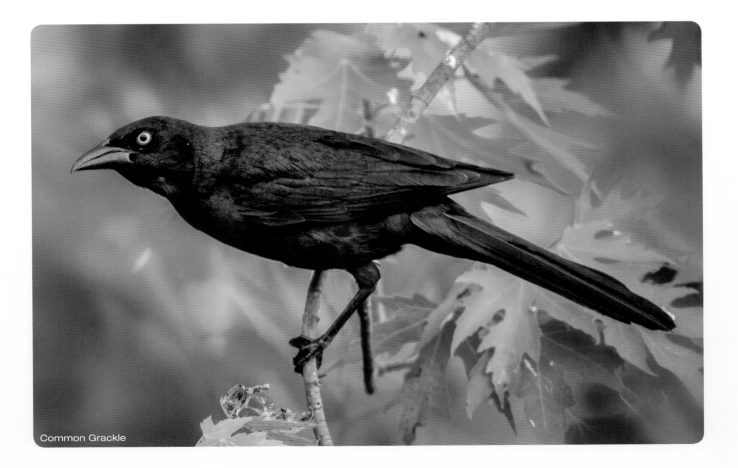

Common Grackle

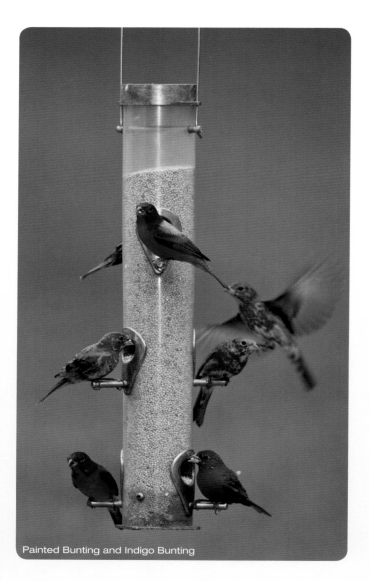
Painted Bunting and Indigo Bunting

DRAWING PAINTED BUNTINGS

Perhaps the most stunningly beautiful bird in North America is the male Painted Bunting. Even though the blue head and red chest are stunning, they don't match the splendor of the lime green coloring on the back of the bird. A true backyard treasure, its French nickname, Nonpareil, means "without equal" and accurately describes this bunting. The male doesn't get his dramatic plumage until the second year of life. During the first year, the young males look just like the females.

Unfortunately, the United States Geological Survey recorded a 60 percent decline in Painted Bunting populations over the past 50 years. Within their range, these birds can be attracted to backyards by offering millet seed in tube feeders.

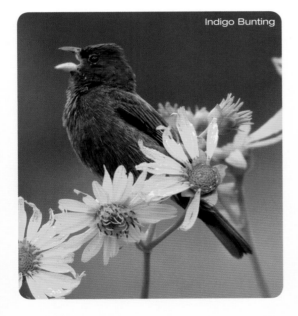
Indigo Bunting

INDIGO BUNTING VISITS

Indigo Buntings are active and energetic birds. For those lucky enough to have them visiting their backyards, they will confirm that they are seen for only a short time each spring. Buntings are well-known insect eaters, so if the weather turns bad in spring, the birds take to foraging at seed and suet feeders. This is when most people notice the bright blue males and dull brown females. After the cold snap or storm, the buntings go back to feeding far away from feeders, and we tend not to see them.

Indigo Bunting males are prolific songsters and will modify their songs of 2–3 seconds to impress the females. Each male has his own unique phrasing. Studies show that young males learn their songs in a social context during their first breeding season. First they imitate their father's song. After perfecting that, they learn the songs of neighboring males and produce a wider variety of songs.

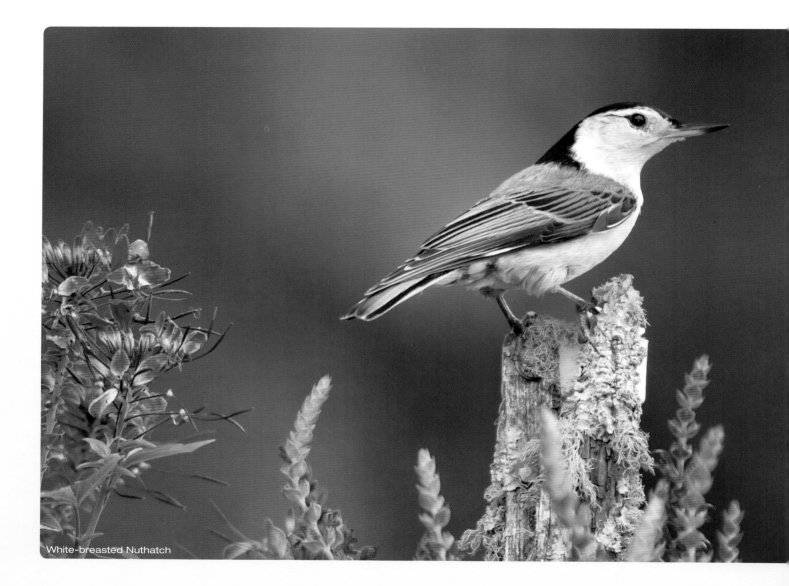

White-breasted Nuthatch

Often the most complex relationship between birds and nature is right in front of us, but we don't see it. For example, Blue Jays are critically important for forest regeneration. A number of studies link the dispersal of oak trees to Blue Jays. Jays collect, disperse and cache oak acorns, and later forget where they hid some. The forgotten acorns sprout into oak trees, which extend the stand from the mother tree almost 400 yards per year.

Blue Jays surpass squirrels as successful oak tree planters. Birds in flight can disperse acorns farther away from the mother tree than a scurrying squirrel. Some botanists even speculate that oak trees with smaller acorns have an evolutionary advantage, as their acorns are more likely to be dispersed by Blue Jays, Acorn Woodpeckers and other birds rather than squirrels.

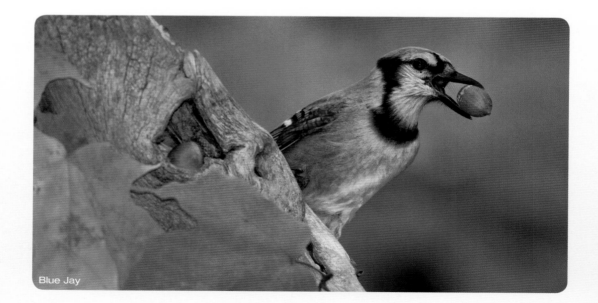

Blue Jay

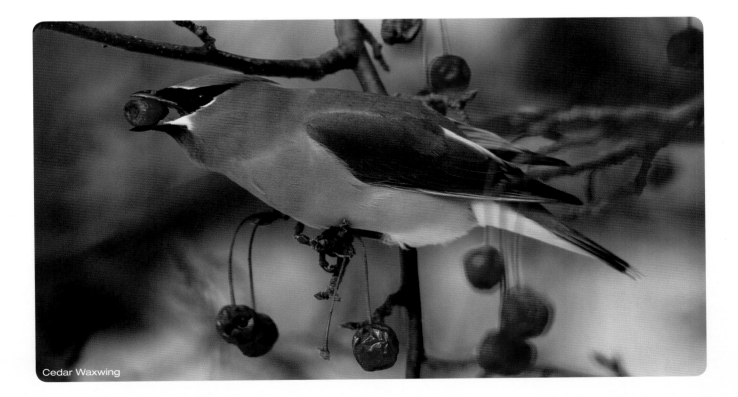

Cedar Waxwing

The same kind of relationship exists between birds, such as Cedar Waxwings, and fruit berry trees, such as High Bush Cranberry and Mountain Ash. The edible fruit of these plants is highly nutritious and surrounds a seed. The bird eats the fruit and inadvertently consumes the seed, transporting it inside its body away from the mother plant. In fact, many of these seeds won't germinate without passing through the digestive tract of the bird first! Later, when the bird eliminates the seed, it lands on the ground well away from the source and starts to grow.

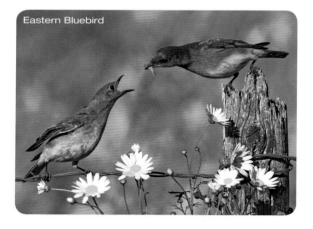
Eastern Bluebird

BIRDS AND BUGS

I don't think we give much thought to the number of insects birds eat. If we didn't have birds constantly gleaning and eating insects, I'm sure we would be overwhelmed by bugs. Every day, birds are constantly on the move, hunting and eating insects on tree leaves and anywhere else they can be found.

A study in Eureka, Missouri, showed that as general bird populations decline, the health of our forests also declines. In this study, large cages were built around specific trees. The cages allowed insects to access the trees but no access for birds. Biologists monitored these trees for two years, and the results were stunning. The caged trees had twice the number of insects and twice the associated damage (such as foliage destruction) than the surrounding natural trees. The caged trees also produced fewer leaves and less fruit in subsequent years than the other trees birds had visited.

So not only do birds enrich a forest habitat with their bright colors and wonderful songs, they also play a critical role in keeping a forest healthy by eating leaf-munching caterpillars and other harmful insects.

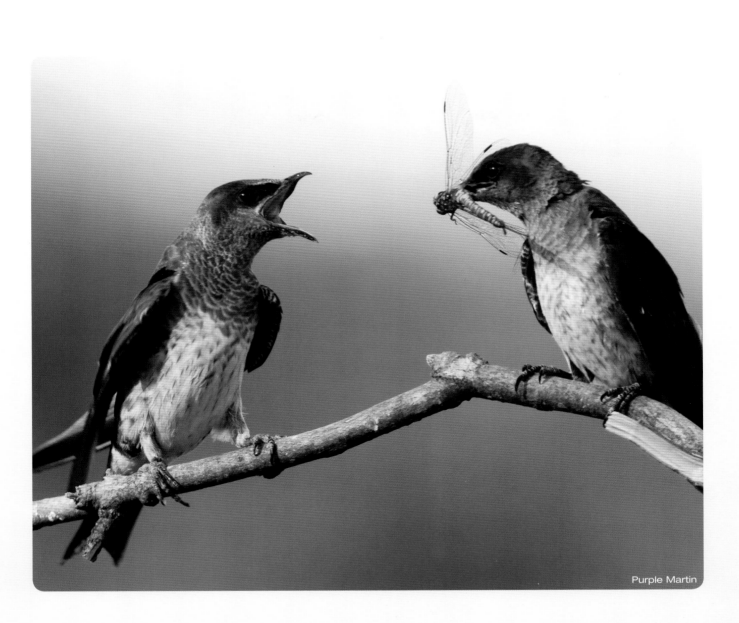

Purple Martin

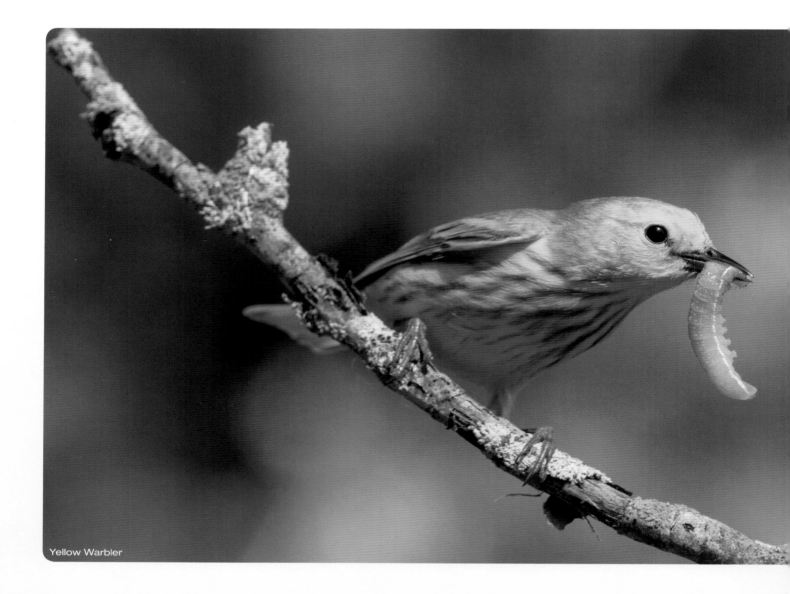

Yellow Warbler

ONE-SEASON PAIR BONDS

Most birds have pair bonds that last at least one season. For example, Yellow Warblers and American Redstarts, two common backyard warblers in many regions, arrive on the nesting grounds without a partner. Males establish a territory and sing vigorously to attract a mate. Once the mate is chosen, the pair stays together and works cooperatively to raise their young. At the end of the season, however, they go their separate ways.

Ducks have short-term pair bonds, often lasting only a couple weeks. The male follows a female around, waiting for her optimal breeding time. This may be upwards of a couple weeks. He follows her everywhere, even in flight. Often several males will follow one female.

When a female duck is building her nest, she mates many times a day—sometimes hundreds of times with one male! If the male is not careful, other males will also try to mate with her. Once she lays all of her eggs and starts to incubate, the males abandon her and flock with other males. Only the female incubates and cares for the ducklings when they hatch.

Wood Duck

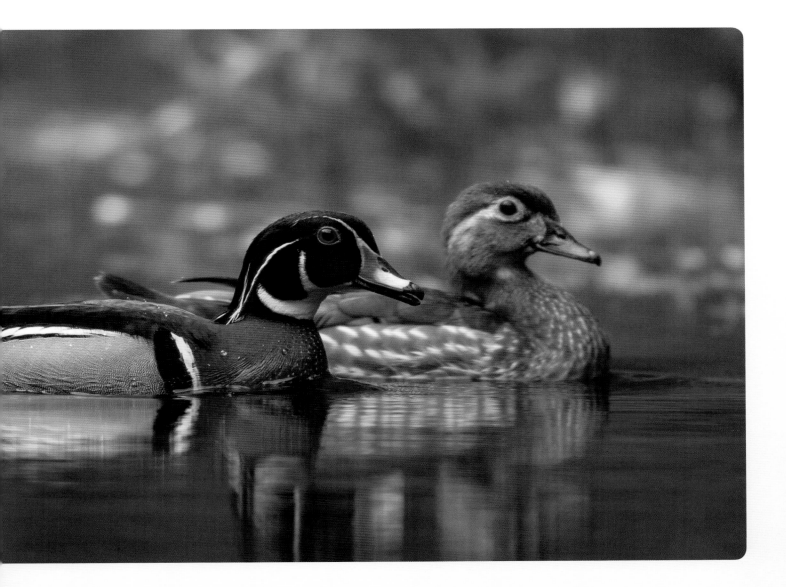

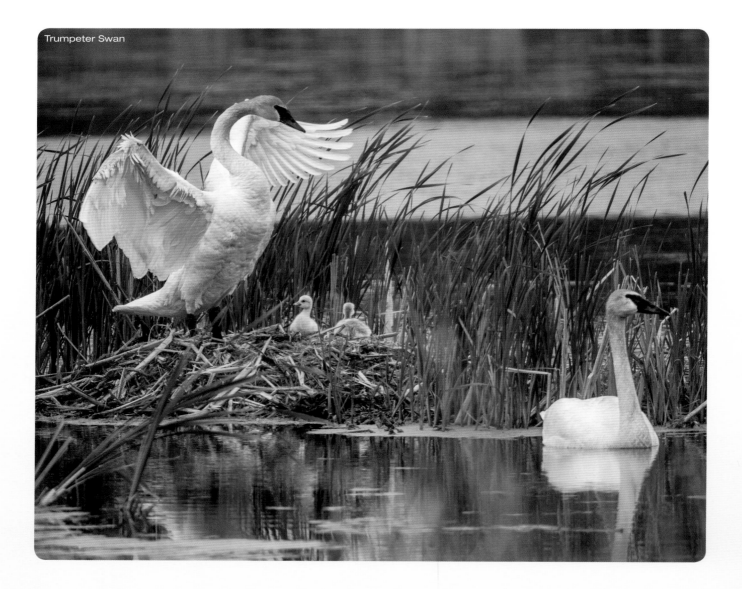
Trumpeter Swan

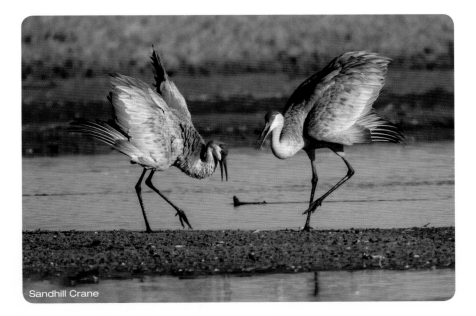
Sandhill Crane

LONG-TERM MATES

It's the complete opposite with geese and swans. The male
is a super-strong partner that aggressively defends the female,
the nest, the eggs and the resulting hatchlings. The male
also stays around to help guard the goslings until they're
full-grown. These birds, along with Sandhill Cranes and
other species, remain with their mates for many years.

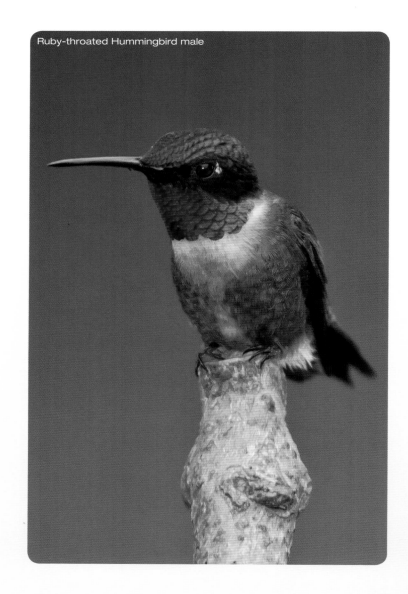

Ruby-throated Hummingbird male

HUMMINGBIRD INDEPENDENCE

Some species have no fidelity to their mates. Ruby-throated Hummingbirds are a classic example. The males and females return to their breeding grounds in spring and set up their own separate territories of ¼–½ acre. The female builds a nest by herself, and only when it's nearly complete will she venture out of her territory to look for a mate. Courtship and breeding are relatively short affairs, and she will solicit copulations from more than one male. Afterward, the female returns to her territory to nest, having nothing more to do with the male.

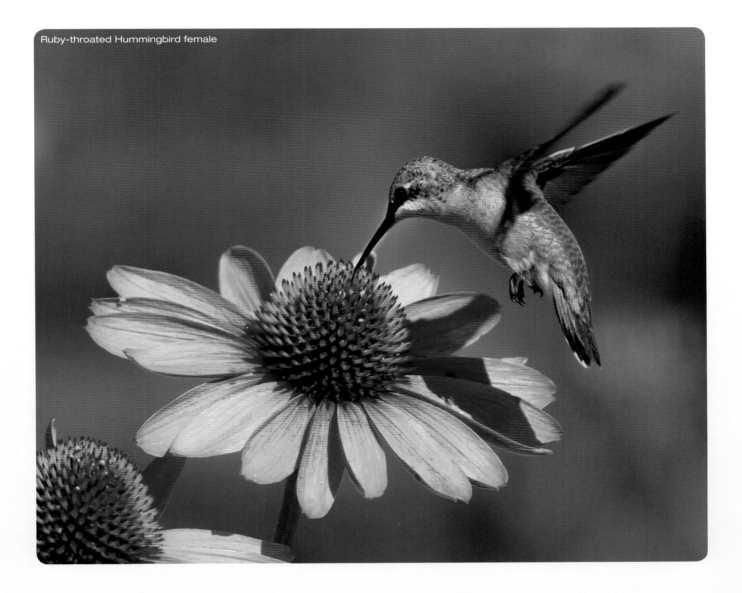

Ruby-throated Hummingbird female

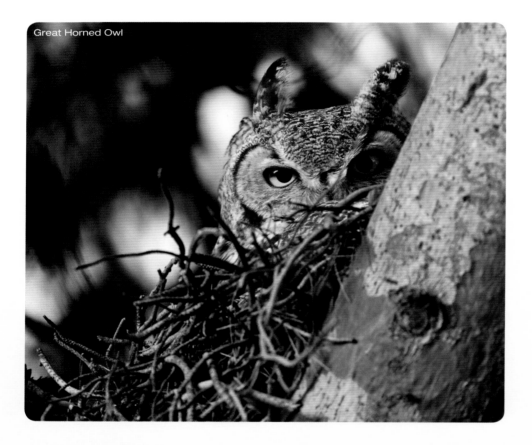
Great Horned Owl

EARLY AND LATE NESTING

Most of our backyard birds are spring or early summer nesters. Great Horned Owls and Bald Eagles are our earliest nesting birds and are the exceptions, nesting even before spring arrives. It's common for them to start nesting in January and February, including in northern states.

Other birds, such as Cedar Waxwings and American Goldfinches, are late nesters. Waxwings are nomadic flocking birds and don't follow the same patterns of movement from year to year. Each year is a new adventure as the waxwings move around, searching for reliable food sources.

In spring and summer they are still in large flocks. This is when mates are chosen for the season. Females choose a male by his feather condition and personal traits. At this time the flock starts fracturing into small flocks of 6–12 birds, and it is well into summer before courtship begins.

Several theories explain the delayed nesting of Cedar Waxwings. Some ornithologists think it's a relatively new behavior response to the nest parasitism of Brown-headed Cowbirds, which breed much earlier. A more probable explanation for late nesting is timed with the seasonal fruit-bearing trees, since the main diet of young nestlings is fruit.

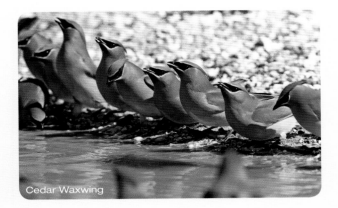
Cedar Waxwing

Courting waxwing pairs sit side by side on a branch and sidestep or hop closer and farther apart. Sometimes they pass a berry or flower petal back and forth, cementing their bond. In many parts of the country, waxwings nest twice per season, first in late June and again in August, well after all other backyard birds have nested.

Even though they hold small territories of upwards of an acre, waxwings are often semi-colonial nesters, which means several pairs nest within close proximity. Some are as close as 20 feet apart. Studies of nesting waxwings show that nesting sites are almost always within easy reach of a reliable food source, such as a fruit tree.

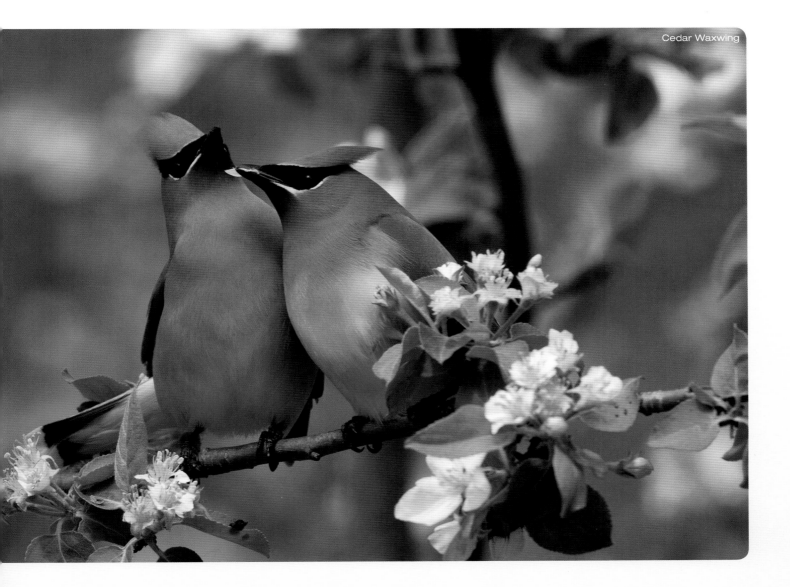

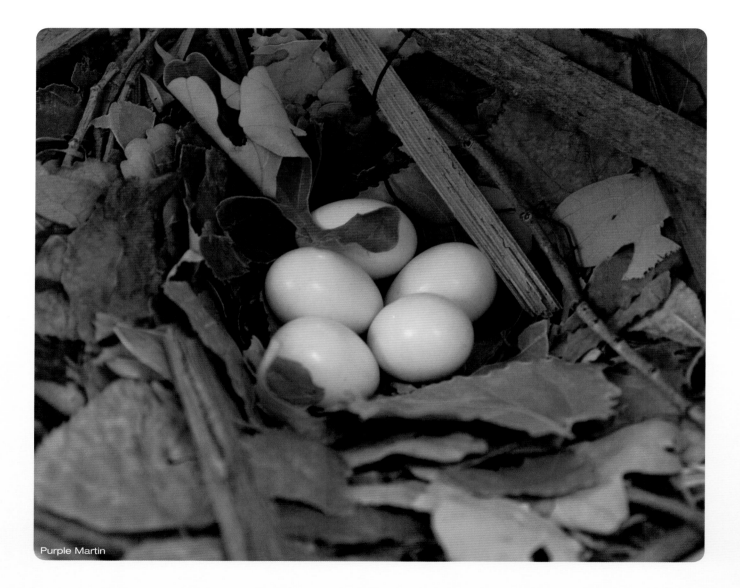

Purple Martin

Bird egg production is rooted in their reptilian ancestry. Today, relatively few vertebrate animals (those with a backbone) reproduce via eggs, and most that do, such as turtles, lay eggs and then leave. Birds, however, are different, and incubation is strictly an avian trait.

Hard-shelled eggs need an external heat source for development to occur within. A parent accomplishes this when it sits on the eggs and its body warmth transfers to the eggs. However, because the insulation of the feathers effectively blocks much of the heat transfer, birds develop a brood patch on their bellies. Feathers are plucked out or hormones cause the feathers to fall out, leaving a bare spot. Arteries supplying warm blood to the area provide the necessary heat.

All of the nourishment and water to support the growing chick are within the egg when it is laid. The unique design of the eggshell allows air to enter and exit, while preventing water from doing the same.

An eggshell is remarkably strong, yet lightweight. The arching shape is the secret to its strength and prevents a sitting parent from crushing it. In one experiment, chicken eggs placed in their normal horizontal position held more than 90 pounds of weight! The same eggs placed in an atypical vertical position were only able to hold over 50 pounds of weight.

American Robin

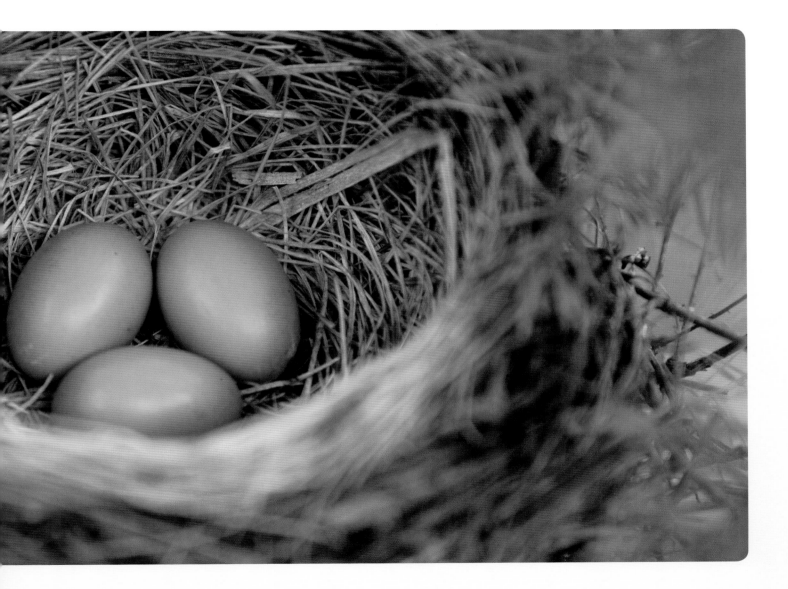

Female birds can produce only one egg per day or every other day during the nesting season. After mating, the developing ovum takes about 24 hours to travel the length of the reproductive tract. Along the way the eggs gradually develop one thin layer at a time, with the eggshell—with or without color markings—forming the last layer, which encloses the egg package.

The first day a mother bird is ready to lay an egg, she sits on her nest and produces the egg in a quick process of a few seconds to a couple minutes. Because she doesn't have a full clutch of eggs in the nest yet, she leaves the nest with the single egg unattended. The next day she returns and lays a second egg. The day after that, she lays a third, and so on until she has laid the entire clutch. In some bird species the process takes a week or more.

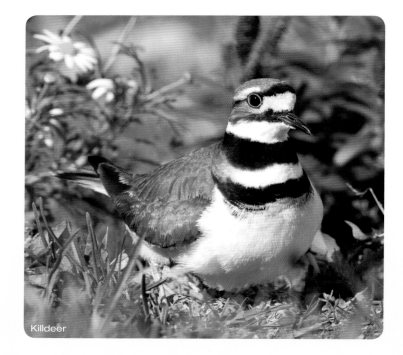

Killdeer

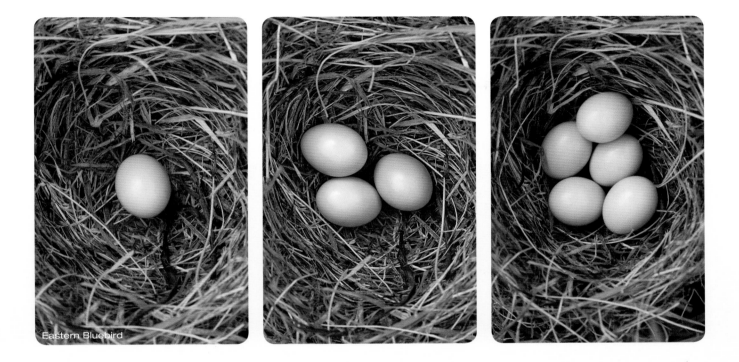

Eastern Bluebird

Eggs in the nest during the period of egg laying are not incubated or protected by the mother. People who notice a nest in their backyard at this time may see one or two eggs and figure the nest has been abandoned. But this is just a natural event before it becomes filled with a family of lively birds.

When compared to the gestation of mammals, egg incubation is incredibly short. In many backyard bird species, babies go from a few cells to fully formed baby birds in just a couple weeks.

Birds make incubation look easy. However, during the incubation period the eggs must be kept at the proper temperature and humidity. In addition, they need to be turned many times an hour. The temperature needed for egg development varies across species, but in general, most bird eggs need to incubate at around 99–100 °F. Most of our back-yard birds incubate their eggs at about 100 °F.

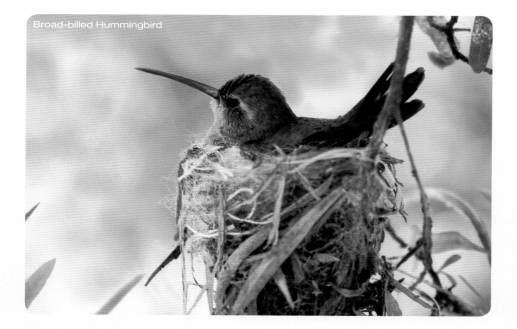
Broad-billed Hummingbird

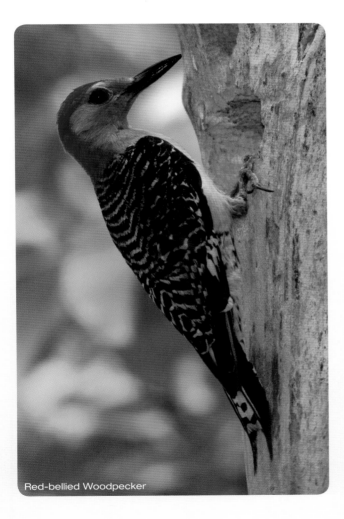
Red-bellied Woodpecker

WHOSE TURN TO INCUBATE?

In many species both the males and females take turns incubating. In some species, such as the woodpeckers, the males do slightly more incubating and all nighttime duty. In other species the female does 100 percent of the incubation.

During the incubation period the parents usually fall silent, with few exceptions. They tend to leave and arrive at the nest secretively. Some ground-nesting birds sneak several yards away on foot before flying to avoid drawing attention to the nest site.

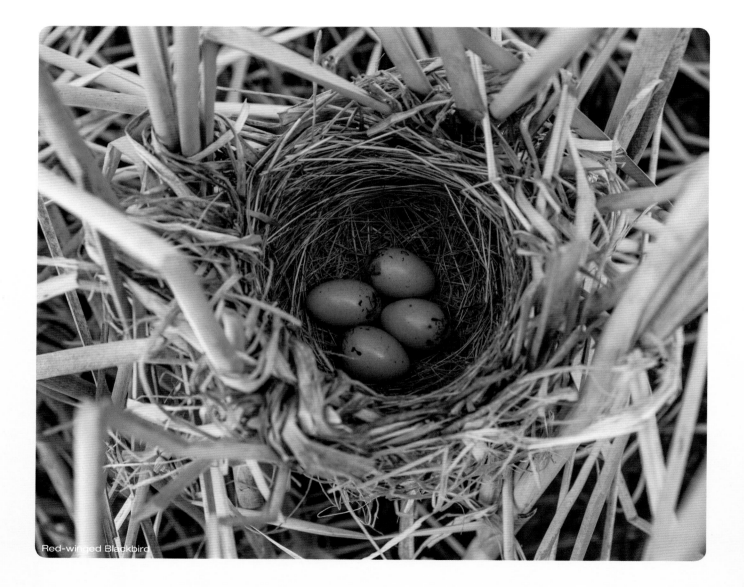

Red-winged Blackbird

CAUTION—BABIES ABOUT TO HATCH!

As the incubation period advances, the more defensive and aggressive the adults become. Birds are more likely to abandon their nest early in the nest-building process and much less likely later, near hatching time. The parents have a lot of time and resources invested by then, and they work hard to ensure the success of producing young.

Studies show that second nesting attempts often produce lower numbers of offspring. In any case, be cautious when visiting a nest and refrain from disturbing the area for long periods. Also be aware that visiting a nest may leave scent cues that can attract predators—although some argue that a human scent at a nest may actually help protect it by warding off predators that shun people.

Red-winged Blackbird

American Goldfinch

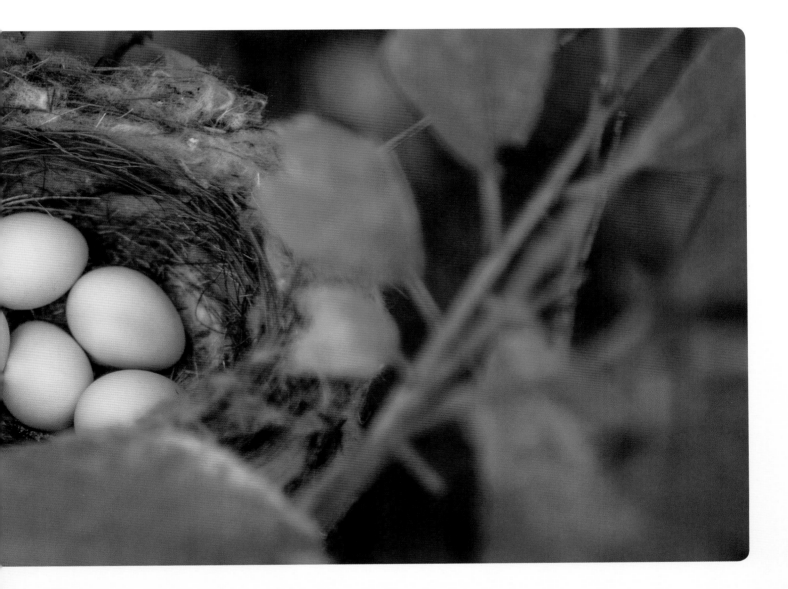

Hatching might seem like a simple process until you consider it from the chick's point of view. By the time a baby bird is ready to hatch, it has grown so large that it completely fills the egg chamber. Its head and beak are tucked tightly against its chest, with no way to lift its head. Its legs and feet are folded up tightly against its body. The chick inside the egg is essentially in the fetal position, making moving around difficult. So how does the chick get out?

Just before hatching, young birds develop a short, pointed, calcareous structure at the top end of the upper bill, called an egg tooth. The chick presses the egg tooth against the shell and starts to rotate slowly around inside the egg, inscribing a thin line around the entire wide end of the egg. The inscribed line eventually cuts through the eggshell, and the chick is able to break free and emerge.

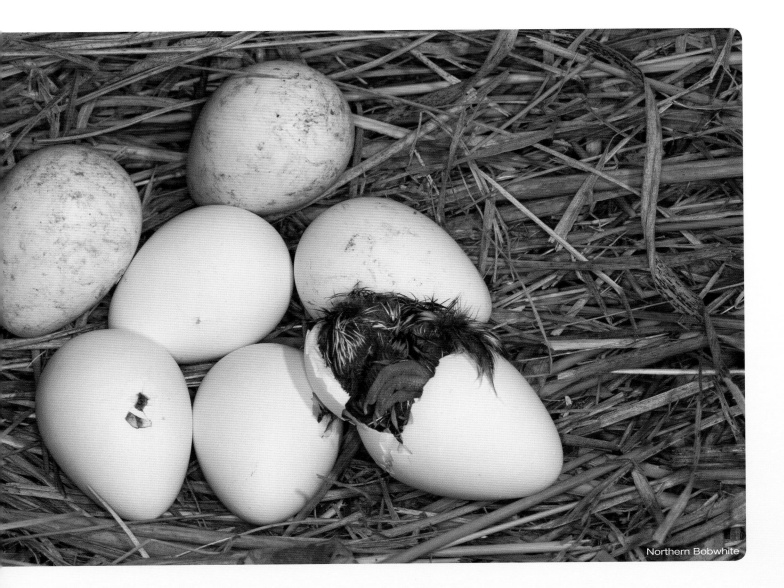

Northern Bobwhite

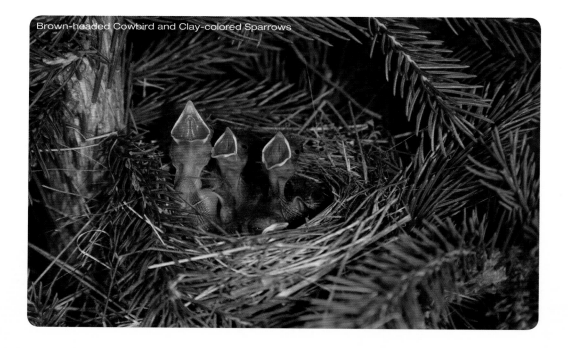

Brown-headed Cowbird and Clay-colored Sparrows

HELPLESS OR READY TO GO

Depending on the species, when baby birds hatch, they are either blind, naked and helpless (altricial), or their eyes are open, they are covered in downy feathers, and they can walk or swim (precocial). Most backyard birds are altricial and need tending by their parents for several more weeks. Species like ducks and geese have precocial chicks that are ready to leave the nest after hatching.

In general, small birds with shorter incubation periods and smaller eggs tend to produce altricial chicks. Larger birds with longer incubations and larger eggs allow more time for babies to develop in the eggshell and have precocial chicks.

BROODING WARMTH

Most of our backyard bird babies can't keep themselves warm because their thermal regulating system isn't working yet and they don't have any feathers. So the parents sit on the babies to keep them warm; this is called brooding. Brooding goes on for upwards of a week after hatching. When the chicks' thermal regulation system is functional, the parents spend less time brooding.

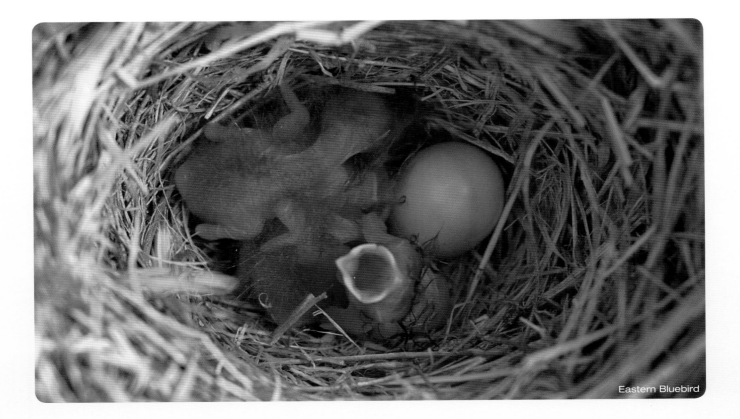

Eastern Bluebird

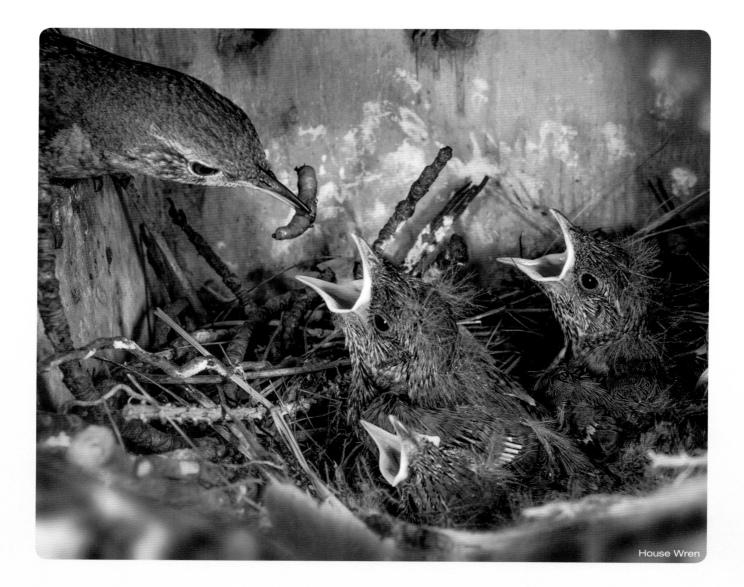

House Wren

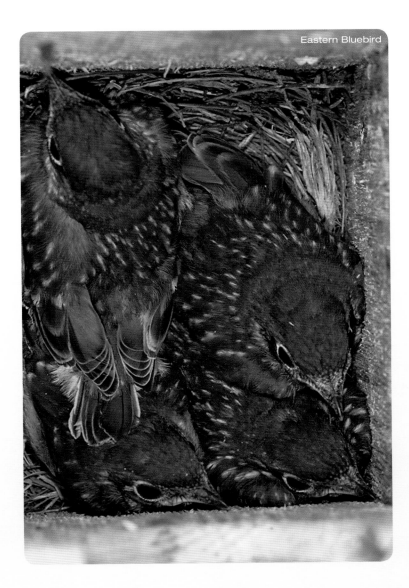

Eastern Bluebird

FLEDGLINGS IN THE NEST

Most backyard birds spend around two weeks in the nest after hatching. This is known as the fledging period. At this stage, the babies are growing quickly but are unable to fly. They spend most of their time sleeping and waiting for the parents to bring something to eat.

There is a burst of activity as the siblings squabble for the food. This is a very vulnerable time for these young birds, as they are often snatched from the nest by a variety of predators. When they are ready to leave the nest, they are officially called fledglings.

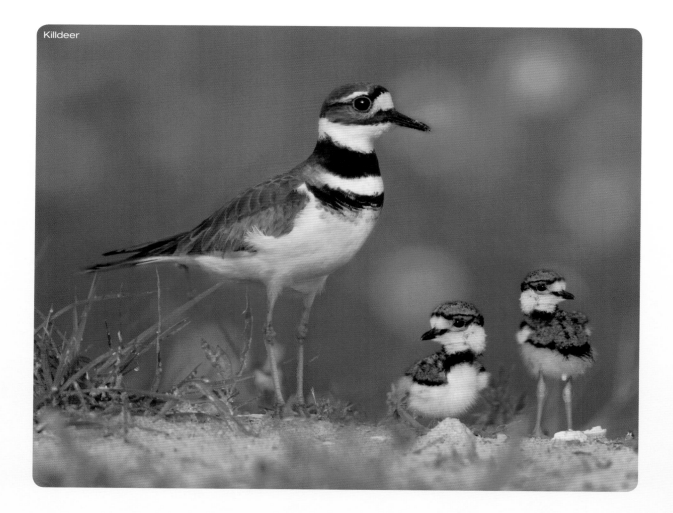

Killdeer

CHICKS OUT AND ABOUT

When our backyard bird babies leave the nest, they often can't fly very well. Although they can fly a couple yards or so, they can't sustain flight. Homeowners may find these birds walking around on the lawn or hiding in the garden at this time, but this is normal behavior. There is no need to pick them up to bring them to a bird rehabilitation clinic.

While the chicks are out and about, the parents are gathering food. They will find and feed their babies when they return, even if they're scattered across your yard. This is another very vulnerable time for the baby birds. House cats and dogs can be a big problem for newly fledged birds. If you see young birds hopping around your yard, it is important to leave them alone and keep your pets indoors for a day or two.

After that time, the chicks are learning to fly and following their parents around, begging for food. Depending on the species, this period can last 2–3 weeks.

Mallard

Mallard

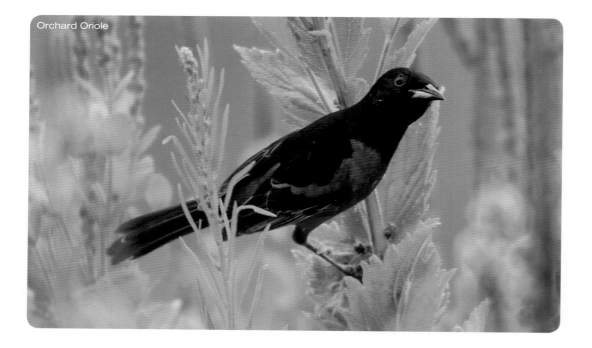

Orchard Oriole

THE NEED TO FLY SOUTH

Most backyard birds take wing in the fall and migrate to warmer climates. But it's not only the cold and snow that drives these birds to leave. After all, many others stay behind and survive winter with relatively no issues. No, the majority of birds head south. They are food specialists, and there are no insects across most of North America during winter, so the birds need to go where the food can be found.

Many of our more colorful birds, such as the warblers and orioles, are true migrators. At the end of the breeding season, true migrators always head south. Most of them end up in the tropics of Mexico, and Central and South America. These birds are called Neotropical migrants.

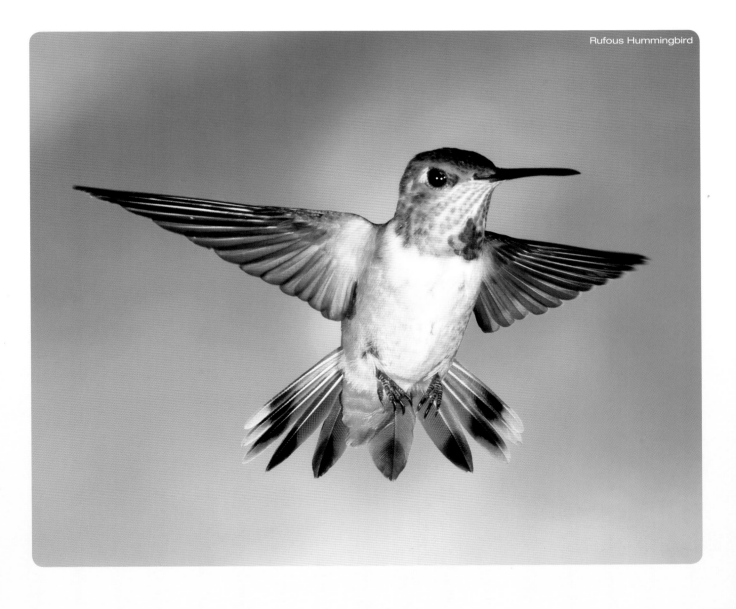

Other birds, such as bluebirds, robins, kestrels and geese, are partial migrators. They often wait until the last minute—when the weather turns wintery or the food runs out—before heading south. Often they go only as far as needed to find food and spend the winter. Sometimes this is just a couple hundred miles.

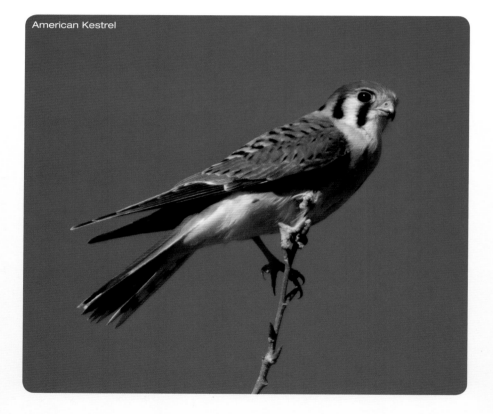
American Kestrel

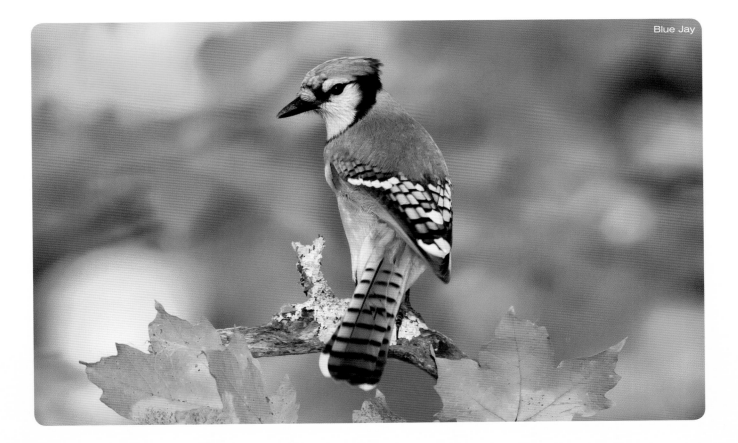

Blue Jay

Some birds that appear to be non-migrators often do migrate. The Blue Jay, for example, moves out of some northern reaches of its range. While leading birding trips in northern Minnesota, I see hundreds of Blue Jays moving southward each fall. They travel in family units, often moving through the forests from tree to tree. This is unlike most migrators, which fly high in the sky.

HUMMINGBIRD MIGRATION

Hummingbirds are well known for their timely migration. Almost like clockwork, these tiny birds arrive in spring and depart in fall. The spring migration of hummers washes over the United States and parts of Canada like a wave. You can follow them on a number of web pages that track their movements.

The male Ruby-throated Hummingbird is always the first to leave at the end of summer. One by one, individual males take to the sky at sunset and fly south all night long. At daybreak the Ruby-throats come down to rest and look for food.

The average hummingbird flaps its wings 70–80 times per second and flies 25–30 mph during migration. Depending on the place of departure and the weather, it can take about 2–6 weeks to get to the nesting grounds.

A couple weeks after the males migrate, the females head south, leaving their young behind. These young birds have never migrated before, but they strike out on their own and somehow find where they need to be for the winter. This is truly an amazing feat!

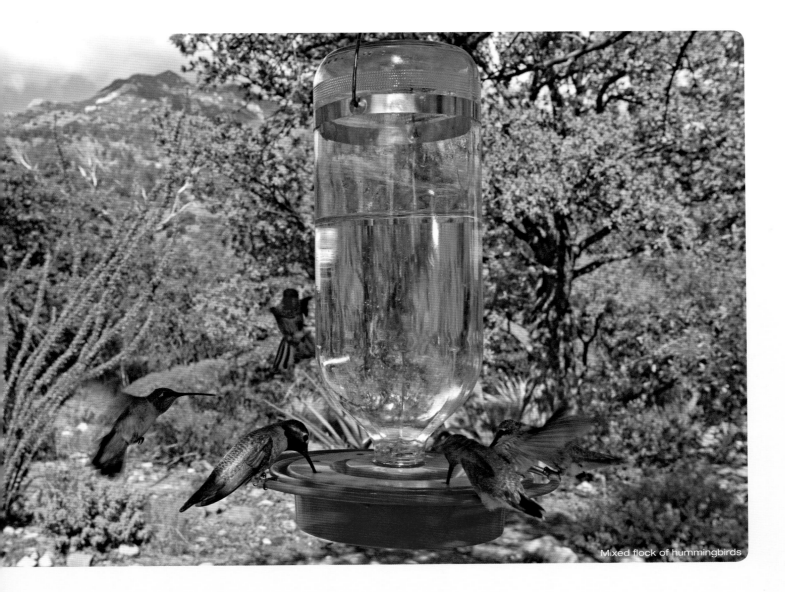
Mixed flock of hummingbirds

133

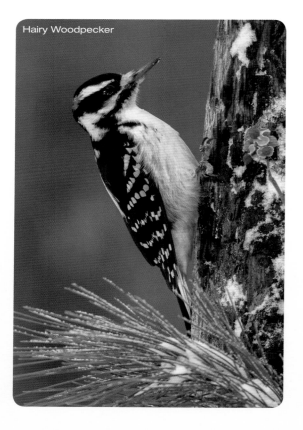
Hairy Woodpecker

Non-migrating species, such as the Black-capped Chickadee, Carolina Chickadee, Tufted Titmouse, Downy Woodpecker and Hairy Woodpecker, are well suited to survive winter. They have the ability to shift their diets and take advantage of seasonally abundant foods. Most of the birds glean much of their nutrition from seeds and dried fruits that remain on trees during winter. They spend their entire day looking for food to replace the calories burned just trying to keep warm.

These birds also search for overwintering insects and their eggs. Many insects lay thousands of eggs in the fall. Wintering birds seek out these eggs, which are a good source of protein.

Surviving winter in the cold and frozen north can be a challenge for tiny backyard birds. Days are short, and nights are extremely long. During daylight hours these birds need to forage very efficiently. They must find the most food in the least amount of time and with the fewest risks. They also need to select the highest quality food that yields the most energy and nutrition so they can build a supply of fat that will fuel them all night long. If they can't do this, they won't survive.

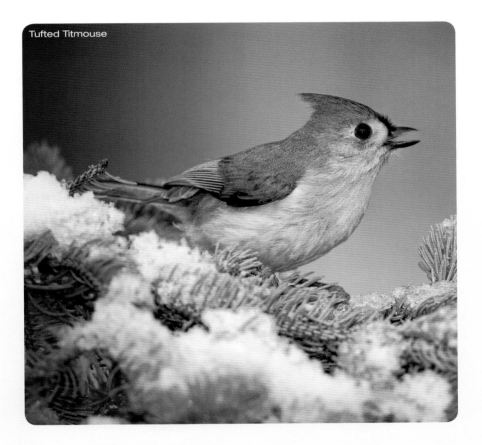

Tufted Titmouse

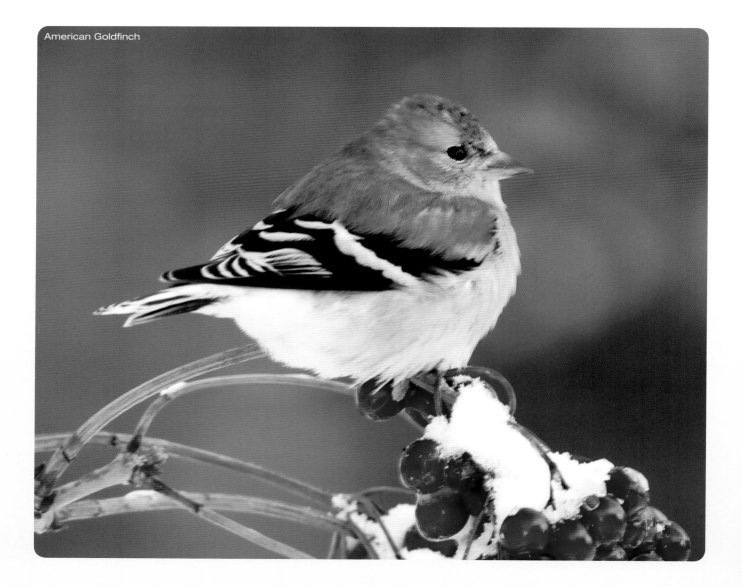

American Goldfinch

DESIGNED TO SURVIVE

In general, large birds need more food than small birds, but small birds need to eat more proportionally than large birds. A chickadee, which weighs about 10 grams, needs about 3.5 grams of food per day, representing about 35 percent of its body weight. A larger jay, which weighs about 100 grams, needs about 10 grams of food daily. This represents three times more food but only 10 percent of its body weight.

This phenomenon is due to the ratio of surface area to volume. Smaller birds require more energy to stay warm and more fuel for their thermoregulation. Because the food items they eat are smaller, they must spend more time and energy gathering food. So chickadees, goldfinches and other small birds need to feed each day and throughout the day, even if a blizzard is raging, but larger birds, such as crows, can go a couple days without eating.

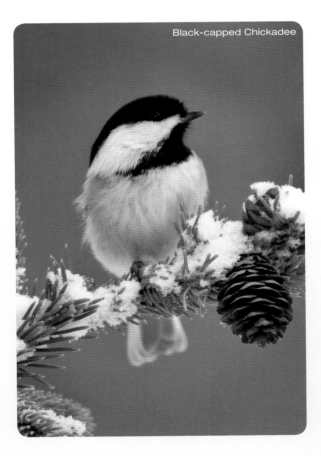

Black-capped Chickadee

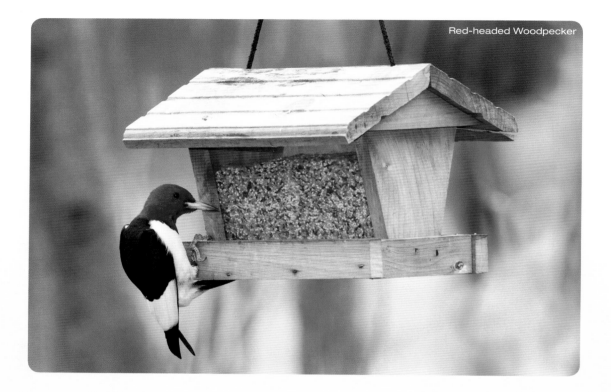

Red-headed Woodpecker

INSTINCTS HELP THEM THROUGH

The natural inclination of backyard birds is to find diverse food sources. For backyard birds, this behavior reduces the time spent in one location and the risk of attracting avian predators.

Several studies in Wisconsin showed that birds living near reliable bird feeders had just a slightly higher survival rate only when winters were exceedingly difficult. This suggests that feeders in warmer climates do not increase the survival of the wintering birds.

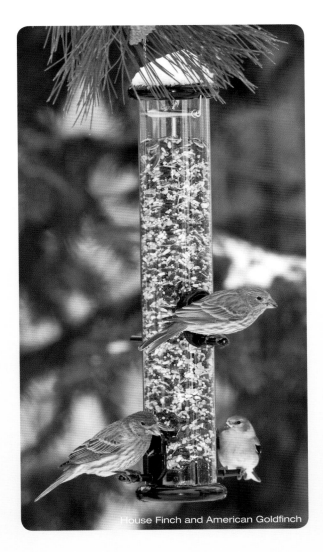

House Finch and American Goldfinch

Further studies show that birds don't become dependent on a consistent food source, whether it's a birdseed feeder for backyard birds, food offerings for pigeons at parks, or food scraps in landfills that crows and gulls like to eat.

In another study, in a woodlot where birds were fed consistently for 25 years, the birds switched to an all-natural food source when the feeders were removed. The following winter, the survival rate matched that of birds that had no access to feeders. Thus, providing a constant source of nutrition to birds doesn't change their innate survival instincts.

Wild birds will always be wild birds, and their instincts will carry them through. Keep in mind that these birds have a history of millions of years of finding food. Your food offerings will not unravel this much time and evolution.

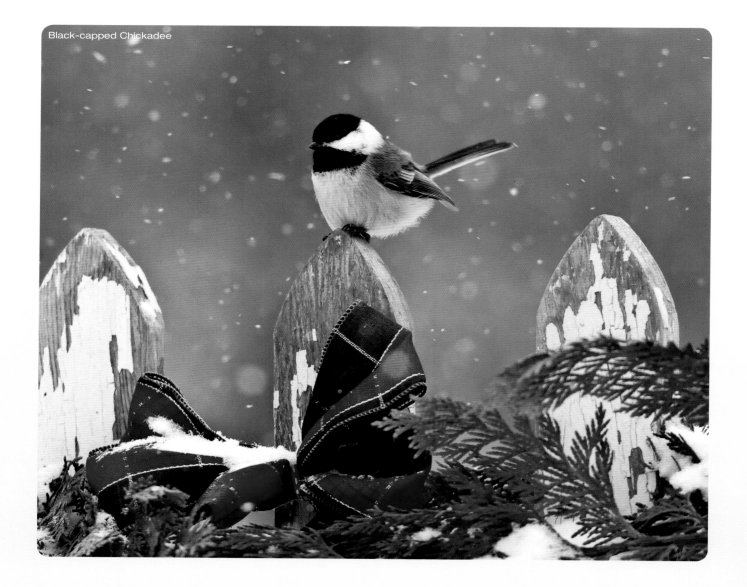

Black-capped Chickadee

Birds maintain body heat by shivering their muscles, which produces heat. The fuel for shivering is fat. If you have ever held a bird in your hands, you felt it shaking. It wasn't shaking from fright; it was maintaining body heat. Shivering in birds and other mammals is just the last remedy for keeping warm.

Our backyard birds have an average body core temperature of 105–108 °F. Maintaining these high temperatures, especially when it's extremely cold at night, is a challenge and takes a lot of fuel. The smaller the bird, the harder it is to maintain the heat in the body.

An Alaska study of Black-capped Chickadees revealed how this species survives extremely cold nights. A chickadee looked for a protective cavity to spend the night; this helped it maintain some heat. The bird also shared cavities with several others to help conserve more body heat.

After entering the cavity, it decreased its shivering, which lowered its body temperature slowly. Periods of inactivity allowed its body temperature to slowly drop, followed by periods of shivering, which maintained the new low temperature. This process repeated until the bird dropped its core temperature more than 10 degrees. The bird finally lost consciousness and went into a state of controlled hypothermia, called torpor. It stayed in this protective condition all night until morning.

In the morning, the inactive periods reduced and the bird shivered more consistently. The core temperature slowly rose, and the bird regained consciousness. This process helped the bird save more than 20 percent of the body fat needed to fuel its heating system. This is vital on mornings with intense blizzards, when a bird can't start hunting for food immediately.

OUR BACKYARD FRIENDS

I can't remember a time when I wasn't fascinated with nature. I have spent the past 30 years of my professional life studying all sorts of wildlife, including birds, and I'm still thrilled and delighted by it all. For me, birds and nature are endlessly interesting!

From the suburbs to the big cities, we still want to see birds and interact with nature. Add the fact that many birds are small and colorful makes them more desirable to appreciate. Many sing beautiful songs that fill the spring air—another great reason to attract them to our backyards.

Feeding birds in our backyard is also fun! We take pleasure in filling feeders with seeds, knowing that soon we'll hear happy chirping and see tiny lives flitting around our feeding stations. I believe we need to see and hear these birds because, after all, they are our wonderful backyard friends!

American Robin

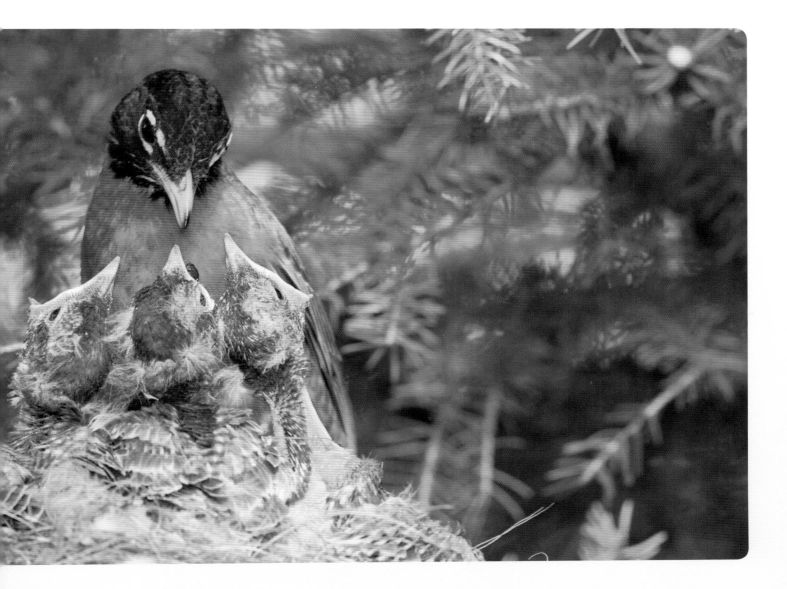

Naturalist, wildlife photographer and writer Stan Tekiela is the author of the popular nature appreciation book series that includes *Cranes, Herons & Egrets*. He has authored more than 165 field guides, nature books, children's books, wildlife audio CDs, playing cards and other products, presenting many species of birds, mammals, reptiles, amphibians, trees, wildflowers and cacti in the United States.

With a Bachelor of Science degree in Natural History from the University of Minnesota and as an active professional naturalist for more than 25 years, Stan studies and photographs wildlife throughout the United States and Canada. He has received various national and regional awards for his books and photographs. Also a well-known columnist and radio personality, his syndicated column appears in more than 25 newspapers and his wildlife programs are broadcast on a number of Midwest radio stations. Stan can be followed on Facebook and Twitter. He can be contacted via www.naturesmart.com.